NATURAL CONNECTIONS: PHOTOGRAPHS BY

PAULA CHAMLEE

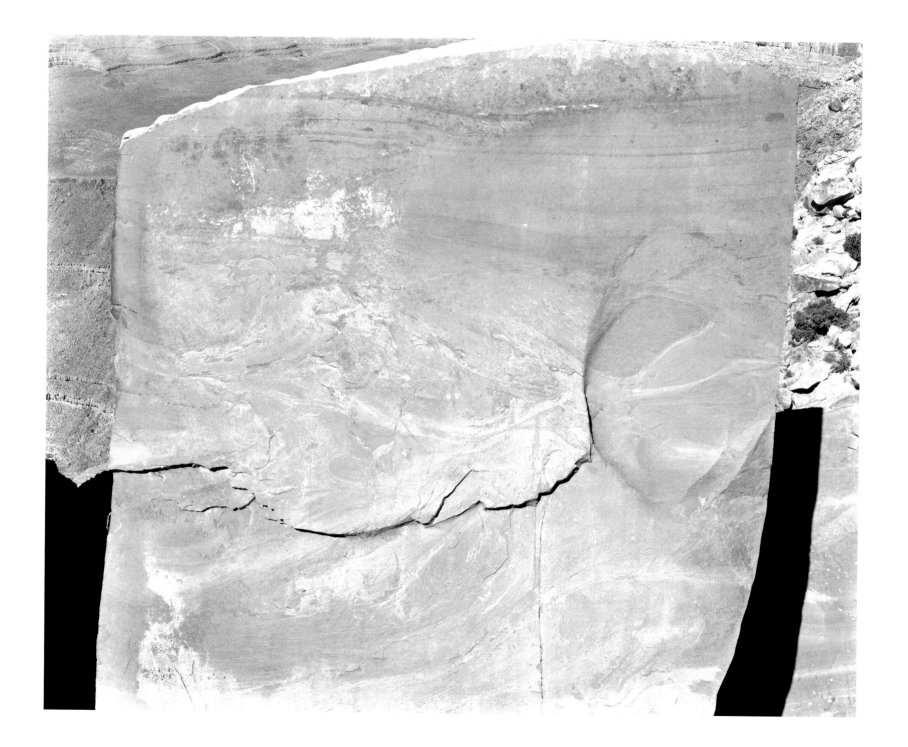

NATURAL CONNECTIONS: PHOTOGRAPHS BY
PAULA CHAMLEE

Accompanied by selections from her journals

essay by Estelle Jussim

LODIMA PRESS
REVERE, PENNSYLVANIA

Frontispiece: *Muley Point, Utah, 1993*

LIBRARY OF CONGRESS CATALOG CARD NUMBER: 94–78796

ISBN 0–9605646–6–7 (regular edition)
ISBN 0–9605646–7–5 (special edition)

PRINTED IN THE UNITED STATES OF AMERICA

To Michael

and

To Wendy and Steve

Making my art is an expression from the soul that awakens and expands my feeling of connection with the world.

PAULA CHAMLEE

THE EVOCATIVE ART OF PAULA CHAMLEE

Estelle Jussim

A passion for primal nature informs Paula Chamlee's brilliant landscapes. The intensity of her vision reverberates like solemn and glorious music. She discovers and records those essences of nature that have survived the depredations of industrial pollution, careless humanity, and military arrogance. Let others depict the wastelands; in her photographs, Chamlee encourages the viewer to share her enjoyment of what has been left of the wild world, a nature untrammeled by greed. Her connections to nature are sensual, strongly emotional, aesthetically sophisticated.

No mere prettiness lingers in these images. Chamlee presents us with the drama of primordial rocky masses, the haunting rhythm of canyons, the intriguing patterns of nature's fecundity, and, always, the resonant detail. When landscape photographs are being judged, an old aesthetic question inevitably arises: is it the subject that is striking and admirable, or is it the form in which the subject is presented that makes for greatness? Chamlee's work comes out of the substantial tradition of the real, yet she has managed to imbue reality with her own characteristic subtleties. There is not only complex subtlety, but it is coupled with an organization of the picture space that invites the contemplation—the investigation—of every inch, a long, slow looking. Each moment of looking at a Chamlee landscape delivers more and more depth, more and more levels of visual meaning, and, above all, a sense of her connectedness to the nature she chooses to represent.

For Chamlee, connectedness is both personal and universal. As she has stated, "Making my art is an expression from the soul that awakens and expands my feeling of

connection with the world."[1] The idea of universal connectedness began to be articulated early in the nineteenth century. The explorer Alexander von Humboldt remarked that what matters in considering physical phenomena is "a knowledge of the chains of connection, by which all natural forces are linked together, and made mutually dependent upon each other."[2] Chamlee's photographs honor that unity. Yet her work goes far beyond the obvious portrayal that Edward Weston made with his nudes like clouds and clouds like nudes. Chamlee's images are demanding for viewers because something is going on in them that is not easily recognizable or accessible. Ambiguities are inherent in her poetic, lyrical expressions of pure form.

Chamlee's natural connections are instinctive. In experiencing these connections, Chamlee has an intense awareness of what is real. It is not surprising that she seems to be plunging into reality with such energy that truths tumble out. She has said, "I am committed to the notion that the deepest truths come from nature, for that is where we are inexorably connected."

She acknowledges the influence of the Apache belief that a spirit flows through all of nature; this is also in profound agreement with the Buddhist proposition that all life contains this force of nature. This spirit, or force, excites Chamlee's recognition of what interests her in a particular vision: "I am interested in tonal compositions that are musical." In the last century, Walter Pater proposed that all art approaches the condition of music: abstract, non-representational, rhythmic, emotional on a non-verbal level. In her photographs, Chamlee demands that "the forms dance across the picture surface." Dance and music are close to her heart. She studied ballet in recent years, and much earlier, she had studied theatre, a medium in which gesture and body movement are, of course, fundamental.

When curators frequently comment that her pictures are "painterly," they are implicitly acknowledging her years of study of painting and drawing. We find her superb management of composition, mass, line, rhythm, broad gesture, and overall energy rebounding through the rectangular format as the outcome of devotion to aspects of painting that are not always represented in photography. While Chamlee's concentration in recent years has been photography, she has continued to draw upon the experience of painting. In both mediums, she favors abstraction, and in photography she chooses black and white. The transference or translation of the color and forms of the three-dimensional world into the monochromatic two dimensions of the black and white print inevitably creates abstraction. Her devotion to black and white relies on its ability to conjure up dreamlike moods. She is involved with the imagination, the soul, the elusive.

This goes far beyond describing subject matter; it involves life rhythms and a response to energetic life forces that can only be experienced. These rhythms and forces are experienced by Chamlee as she makes her pictures, and, through them, they can be experienced by the sensitive viewer. About her landscapes, Chamlee believes, "They are

not photographs of the landscape as much as they are intuitive expressions inspired by nature and made manifest through an 8x10 camera and contact prints."

Is there a contradiction between her rigorous pursuit of the real and her delight in abstraction? No. Photography depends upon outward reality, yet, as Chamlee moves about with her 8x10 camera, shifting its cumbersome bulk here and there to find the most exacting composition on the ground glass, it is the forms that move with her, until the real and the abstract rhythmically connect across space and time. Chamlee's sense of abstraction (for example, Plate 7), often evokes a reality we learned through Whistler's paintings and oriental screens: that nature creates the most remarkable arrangements—patterns that can be recognized by a sophisticated artist.

Paula Chamlee came to photography relatively late, realizing her artistic bent after years of other pursuits. Born in 1944, she grew up on a 640-acre wheat farm on the high plains of the Texas Panhandle. "My early childhood was filled with much time outdoors on the farm, in solitude and in the huge open spaces of the expansive flat landscape." That Texas landscape, with what she calls its "stark, clean beauty," has remained distinct in memory, especially when she talks of "walking through the rows of tall wheat before harvest, the sweet smell of the earth after a much needed and hoped for rain, the magnificently formed clouds in clear and deep blue skies…we would, in summer, lie on the grass at night looking at billions of stars in the deep, clear, endless space."

That clarity is distinct in her photographs, but it is a struggle against the dust and the chemical-laden smog that, in so many locales, have obliterated that blue sky of memory. Even the clouds, she notes, no longer form the kinds of shapes she remembers. Humanity has so badly fouled its own habitat that what Chamlee finds of unspoiled nature becomes all the more precious. Surely, her background has influenced her attraction to the vast unpeopled places and spaces of the American West, as well as for the tucked away, intimate, unpeopled places she has found in Southern and Eastern locales. That influence is not necessarily revealed in specific images: "The influence is more on my way of being."

Chamlee spent two decades in the South, in Mobile, Alabama, with her first husband and two children. It was a comfortable life, safe, secure, but her marriage ultimately failed to encourage personal and artistic growth. She had always had a healthy love of travel and adventure, to satisfy which she dropped out of Texas Tech University in 1965, where she had been studying speech and drama, to serve for three years as an airline stewardess (as flight attendants were then called). Returning to school part-time at the University of South Alabama in 1981, she majored in studio art, with an emphasis on painting. By some good fortune, she took a course in the history of photography with Dr. Michael Thomason, who exposed his students to photography with vigor and intelligence. Among the many books Thomason had assembled for the course was Beaumont Newhall's classic *The History of Photography*. For the first time, Chamlee

saw reproductions of photographs as art and realized instinctively that this was something she wanted to pursue. Browsing through Newhall's book, she came to the work of Edward Weston: his cloud that looked like a nude, a nude that looked like a cloud, the half of an artichoke filling the entire print, the sharply detailed Oceano dunes.

Encountering Weston's photographs was an epiphany for her. She responded to his clarity of vision, precision of detail, and elegance of composition. Over time, Chamlee has tried to determine exactly what was so stirring and powerful about seeing these Weston images. She has concluded that it was Weston's understanding and response to universal life rhythms, as she believes them to exist—something he saw in all his subject matter. Her intuitive response was so strong that she felt compelled to begin working in the photographic medium. Yet she recognized how much she had to learn, for one does not simply wander out into the landscape and "make a Weston," even if one wanted to. The young Beaumont Newhall had discovered this truth when he naively tried to do just that; the amused Weston kindly took him by the hand and introduced him to the magic of the darkroom, where patient dodging and burning in were required for the beauty of every Weston print.

Quickly, Chamlee learned some basic technical darkroom procedures. Then she began to photograph people, places, and landscapes in and around Mobile. In describing her progress, she relates: "The first pictures I made as an artist were with a 35mm camera. Then one day I saw the 2¼ negatives of another photographer, and I said, 'That's better.' So I started working with a 2¼ camera until, a short time later, when I saw a 4x5 negative, I said, 'That's even better.' In 1987, I began to work with a borrowed 4x5. Then I saw 8x10 contact prints, and said, 'That's better yet.'" Chamlee began to work with an 8x10-inch view camera and has continued to use it exclusively, making occasional 4x5 and 5x7 negatives by employing appropriately-sized reducing backs on the 8x10.

One of the values of this kind of large format photography is the production of contact prints, as opposed to enlargements. Weston's influence helped to establish a select group of photographers who were devoted to the expansion of vision the larger format allowed. Among the f/64 group, many of whom were advocates of the contact print and "straight photography," Edward Weston was an eloquent spokesman. His influence continues today, with adherents of this approach committed to great depth of field, development of individual negatives, and black and white contact prints requiring special papers. Chamlee notes with enthusiasm that contact prints—on contact printing paper—have a richness that "imparts a kind of glowing presence that I have never seen in any enlargement."

In 1988, after her graduation from the University of South Alabama with a B.F.A. in painting, she traveled to the West Coast and photographed in Yosemite National Park. Her images of the West, along with her other work, were exhibited in various art centers in and around Mobile, and

she became an instructor in photography at the Fine Arts Museum of the South in Mobile. Then came a crucial event: the renowned photographer, Michael A. Smith, came to Mobile to conduct a workshop, teaching the tenets of f/64 in its contemporary guise. As a teacher, he was inspiring. Later, through correspondence, they recognized in each other a kindred spirit. They married in 1990, and Chamlee left Alabama to join Smith in Pennsylvania. In that first year, they traveled and photographed together for six months throughout the western United States and Canada.

Saying that they "photographed together" may be misleading. They may have visited the same sites in Smith's specially adapted old fire company pickup/camper, but their photographs are significantly different. Chamlee carried her own 60-pounds-plus of equipment and went off in her own direction. Comparing their series of individual images of Canyon de Chelly, for example, reveals differences that may be, at least partly, the result of gender differences. While it is true that many curators and collectors frequently comment on what they see as a feminine quality in many of her images, do we dare say that only a woman could see what Chamlee presents? One response offered to such a question is that men are usually more analytical and concise, seeing things in a straight line or grid without areas of ambiguity, while Chamlee's prints are evocative because they suggest many other possibilities. Another approach is to claim that males are inherently aggressive while females are receptive. The problem is to discover if, and how, such characteristics

reveal themselves in pictures. This argument over innate characteristics will probably never be settled.

The comments that her work has a feminine quality have aroused Chamlee's curiosity. Whether male or female, those who have these reactions and make these comments and observations respond positively to that quality. Chamlee is understandably cautious in making generalizations about gender differences, for while she feels that even if such differences can be demonstrated to be biological, culture also influences individuals to an almost indefinable extent. It is not difficult to believe that men are more aggressive than nurturing; women are presumed to be more nurturing than combative and warlike, all characteristics supposedly having a natural, biological origin. Chamlee insists, however, "While this is a truth, it certainly is not true for *every* man and *every* woman."

In beginning to talk about specific images, critics have always been conscious of the difficulties involved in assessing and describing what are nonverbal artifacts. In Chamlee's pictures, there is a mysterious quality which is absorbing, even seductive, with much more residing in each image besides the first level of "subject." What the next, deeper levels evoke is, of course, dependent on the subjective responses of individual viewers. Essentially, Chamlee does not make pictures with preconceived notions about what she expects each viewer to get from them. On the contrary, she knows that each viewer will bring his or her own life experience and interests to a visual connection with her

images. "I expect that some viewers will bring so much to their experience of viewing my photographs that they will get from them things that I cannot imagine."

Many of Chamlee's photographs are subtle, full of complex relationships and fragile tensions, and she is unafraid of sensuality. It is probably safe to consider Plate 19, "Near Escalante, Utah," as the most revealingly feminine of this collection of Chamlee's landscapes. Its flaming, vulva-like central form is unabashedly sexual. About "Near Paulouse, Washington" (Plate 11), she remarks that when she discovered the field of wildflowers she was "immediately stimulated by the sensuous textures, the delicate subject matter, the subtle spacing between the light and dark areas—all creating a kind of liquid, flowing movement that felt poetic and musical. I felt stimulated by rhythms in continuous soft vibration."

"Yellowstone, Wyoming" (Plate 14), again displays an extraordinary ability to visualize complexity, from the shadowed foreground, through the anomalous irregularities in mid-ground, to a strong horizontal streak, and lastly, to the densely packed conifers at the very top echoing the dark foreground shape. This is a picture that rewards careful and thorough examination and study, as do all of Chamlee's works.

Plate 3, "Near Nicasio, California," and Plate 31, "From Romana Mesa, Utah," reveal Chamlee's use of the 4x5 and 5x7 as opportunities to draw the viewer in for a more intimate viewing experience. "I think of my small contact prints as little gems. I often make these small pictures of very large spaces and grand views, somehow forcing the viewer to relate differently to these spaces, spaces usually seen in big enlargements. I believe that one does not make a picture 'grand' just by making it very large in scale."

Obviously, no amount of inspiration can replace technical perfection, and Chamlee's prints are marvels. The experience of viewing Chamlee's prints is enhanced by her technical mastery, which includes the following choices: great depth of field for sharp detail from front to rear, carefully selected edge-to-edge composition, Super XX film, with its long, smooth tonal scale providing substantial latitude in exposure and development, meticulous development of individual negatives, and finally, most crucially, printing on Azo paper. With these materials she makes prints with an astonishing range of midtones. Unfortunately, the manufacture of Super XX has been discontinued (an exigency for which she and Smith prepared by buying a large supply of the last run of the film), and the future availability of Azo is in jeopardy. Chamlee, determined and inventive, will undoubtedly continue to make exquisite prints even when these specific materials are gone, but these hazards of the profession will ultimately demand a different set of technical choices that will profoundly alter not only the process of previsualizing an image, but the actuality of the end result.

Chamlee, however, is not an advocate of "previsualizing" in the rigid way that acolytes of Ansel Adams' zone system

follow. Her working methods are much more fluid. For example, she develops film by inspection rather than by a predetermined formula of time and temperature. Edward Weston did proselytize photography as an act of previsualization, even pretending now and then, in his writings, that it was possible to previsualize a print in every detail. He also stated that "An abstract idea can be conveyed through exact reproduction: photography can be used as a means."[3] What was desirable in photography as well as in painting was to create "an art that would evoke reality rather than imitate it."[4] Chamlee's photographs evoke the sensation of reality. They are not rigidly intellectualized. She observes, "They are not about ideas. They are not about concepts. They come from the heart—the part of one's being that transcends things one can understand…They are not really about 'things' at all. They are photographs that deal with both the natural and the human-made world in all [their] complexity, mystery, and delight…[they] are abstractions of reality, thus becoming realities of their own."

Reality, abstraction, power, delicacy, rhythmic chords of contrast, visual music—here is a photographer with a vast repertory. Paula Chamlee is an unusual woman, greatly gifted, whose own natural connections to the world give us the opportunity to forge our own connections through her photographs. She deserves our gratitude and admiration.

NOTES

1. All quotations attributed to Paula Chamlee are from her manuscripts and letters.

2. Quoted in Barbara Novak, *Nature and Culture* (Oxford University Press, 1980), p. 67.

3. Edward Weston, *Omnibus*, ed. Beaumont Newhall and Amy Conger (Salt Lake City: Gibbs M. Smith, 1984), p. 69.

4. José A. Argüelles, *Transformative Vision: Reflections on the Nature and History of Human Expression* (London: Shambhala Publications, 1975), p. 178.

THE PHOTOGRAPHS

and

JOURNAL ENTRIES

1. SUPERSTITION MOUNTAINS, ARIZONA, 1990

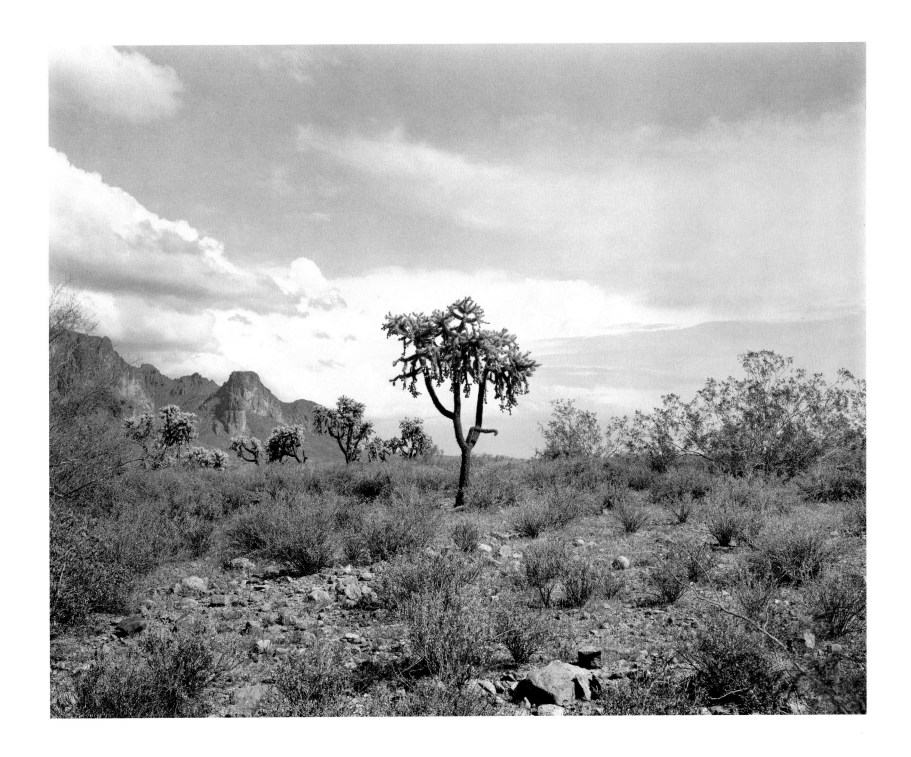

2. SAN RAFAEL VALLEY, ARIZONA, 1990

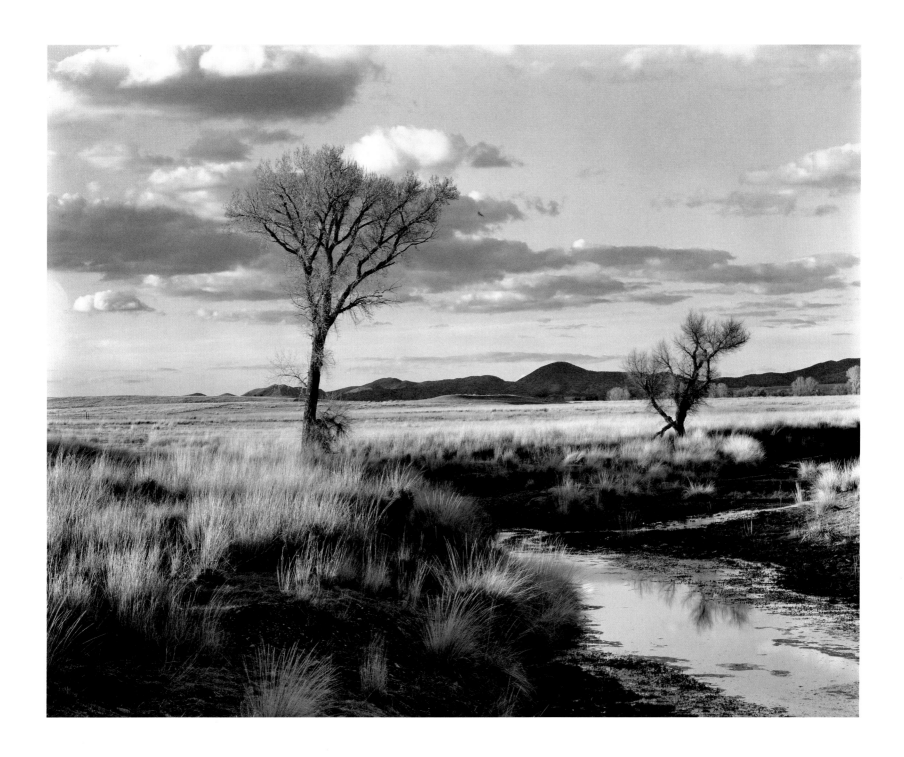

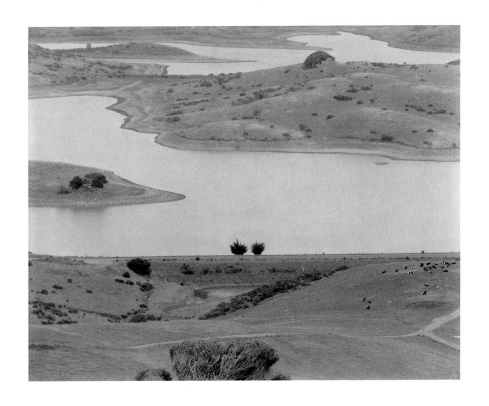

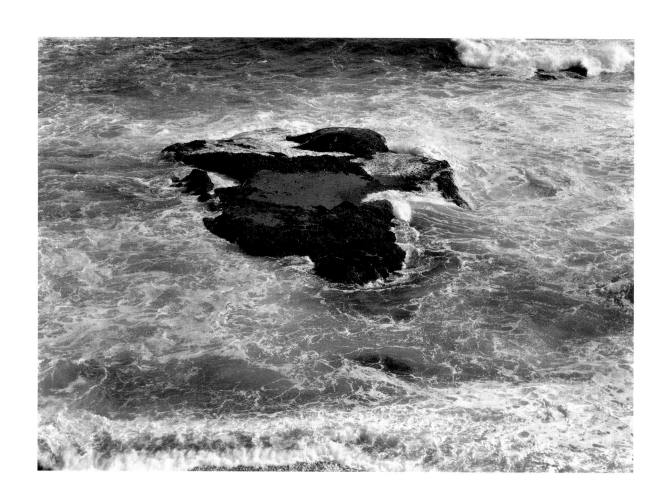

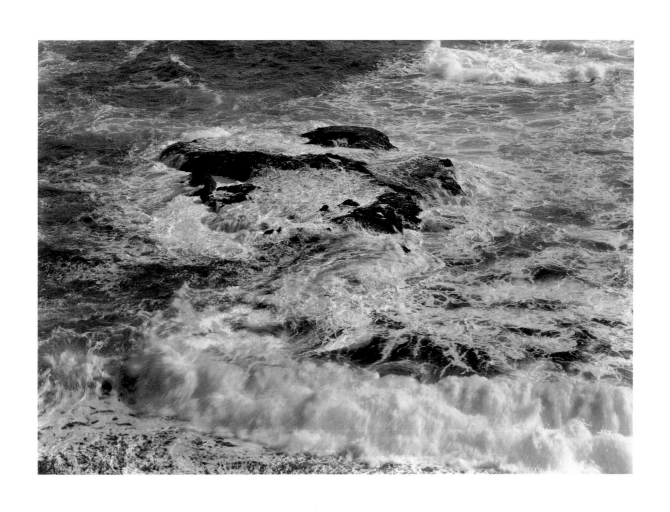

5. YELLOWSTONE, WYOMING, 1991

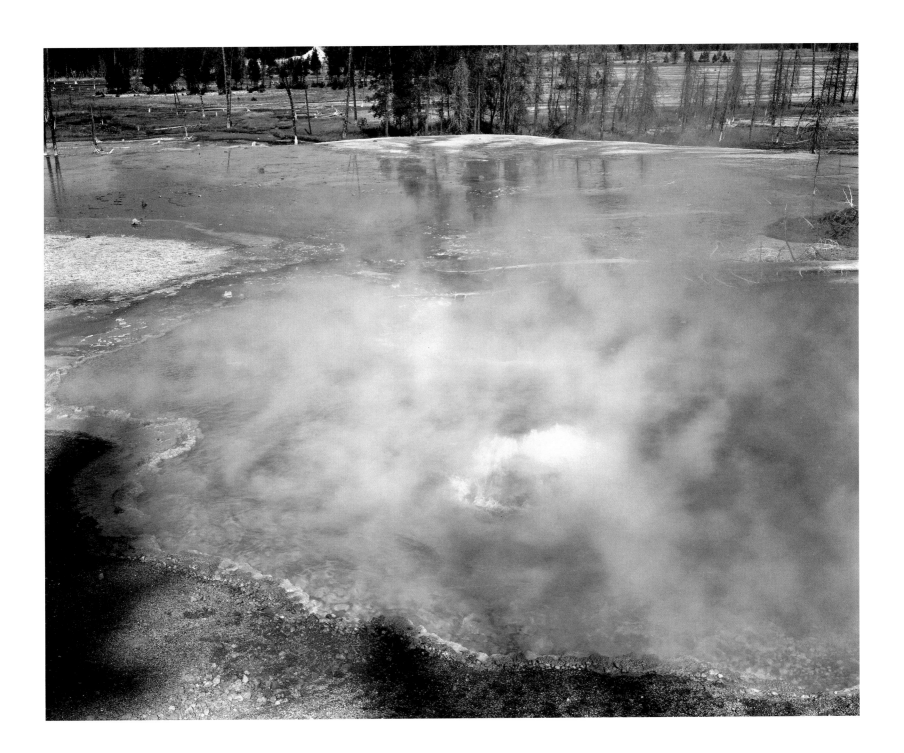

September 29, 1991 *Woody Creek, Colorado*

I love looking at the world—there is so much to learn from looking. I see the world as if it were one continuous canvas, a constantly unfolding painting—and I stop now and then to selectively put edges around parts of it, abstracting vignettes from the world, parts from the whole that conjure up larger impressions, emotions, and responses.

The decisions I make about what to include within the edges of my photographs are made intuitively, trusting my own personal life rhythms.

Although I view things on the ground glass as if they were abstractions, I am always drawn first to something very recognizable and specific before I set up my camera. It may be an object or the spaces between objects, but as soon as I start looking on the ground glass, the scene before me is transformed. Now the looking becomes a new adventure. The subject matter that drew me in is no longer of primary importance as I am making discoveries of visual relationships that I would not otherwise have made.

June 8, 1993 *Canyonlands, Utah*

Today, I trudged out onto the far point overlooking the vast canyons below, slowly and carefully wending my way across a rugged, undulating sandstone obstacle course. With over 60 pounds of equipment on my back and shoulders, I wondered if I would have energy left for looking and photographing once I got there. As I finally reached my viewpoint, I paused to catch my breath and began the task of setting up the 8x10 once more, keeping lenses and film holders away from the thousand-foot drop looming below me. I attached the dark cloth, selected and placed the lens, and opened the shutter. Then, as I took my first look on the glowing ground glass, I was re-energized, exhilarated and consumed by the wonder of looking. I turned the camera on the tripod, looking at everything abstractly, equally, until some new discovery seductively revealed itself. I was unaware of the subject matter; it was no longer important; it had drawn me here and that was enough. Even if I had made no negatives today, I was having the experience of seeing in a way that I would not otherwise have had. The discoveries in these moments would nourish my visual memory and life experience, emerging as something new, either today or perhaps a year from now. It is always worth the cumbersome walk.

6. TOROWEAP, GRAND CANYON, ARIZONA, 1991

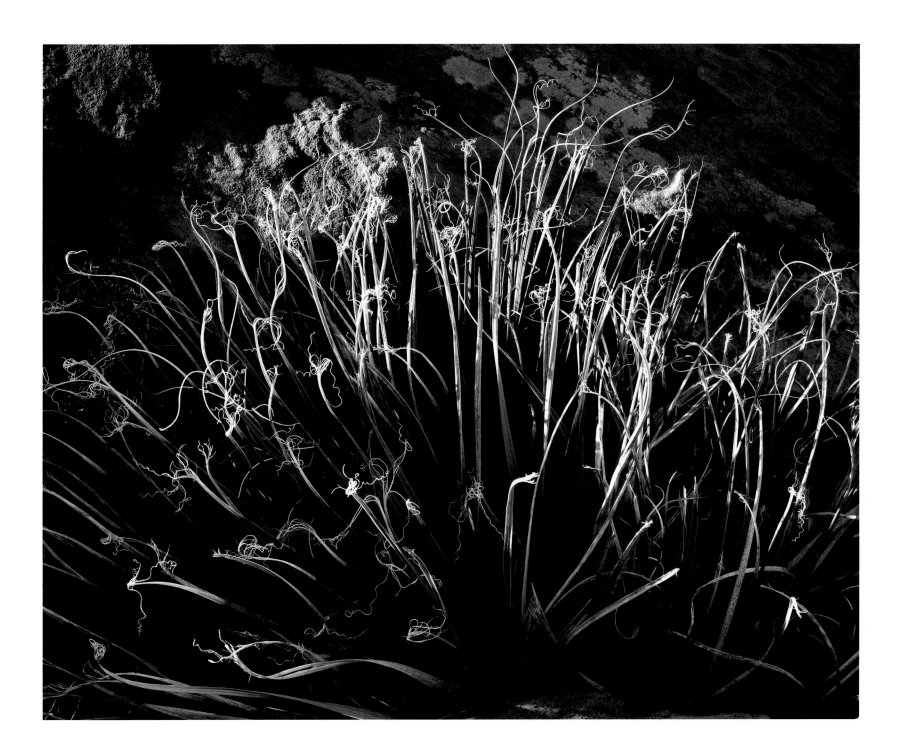

7. WOODY CREEK, COLORADO, 1991

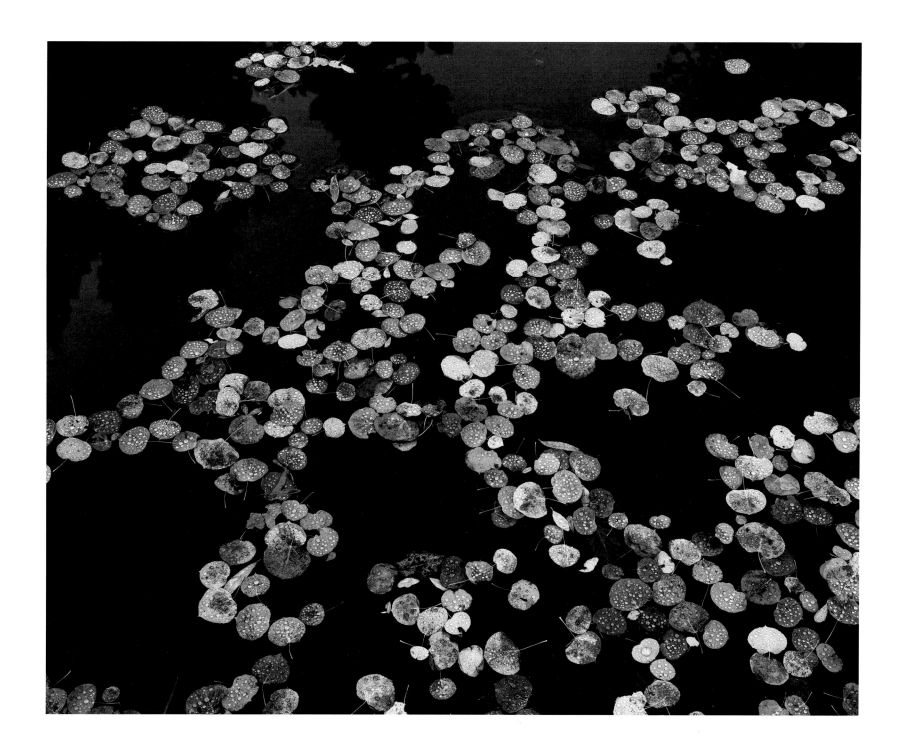

8. YOSEMITE, CALIFORNIA, 1990

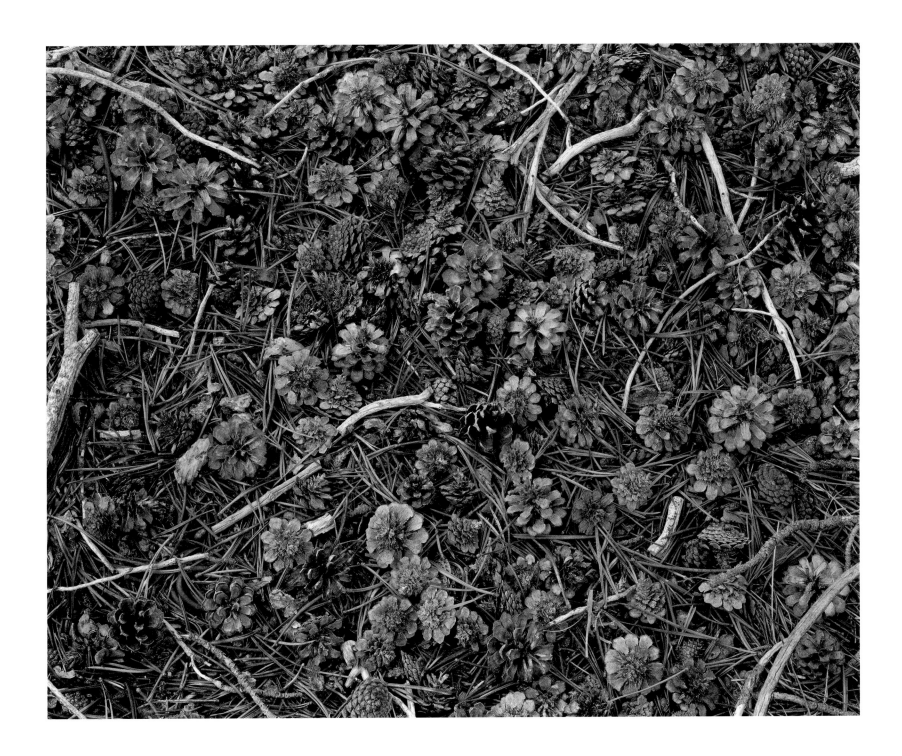

9. CARMEL HIGHLANDS, CALIFORNIA, 1993

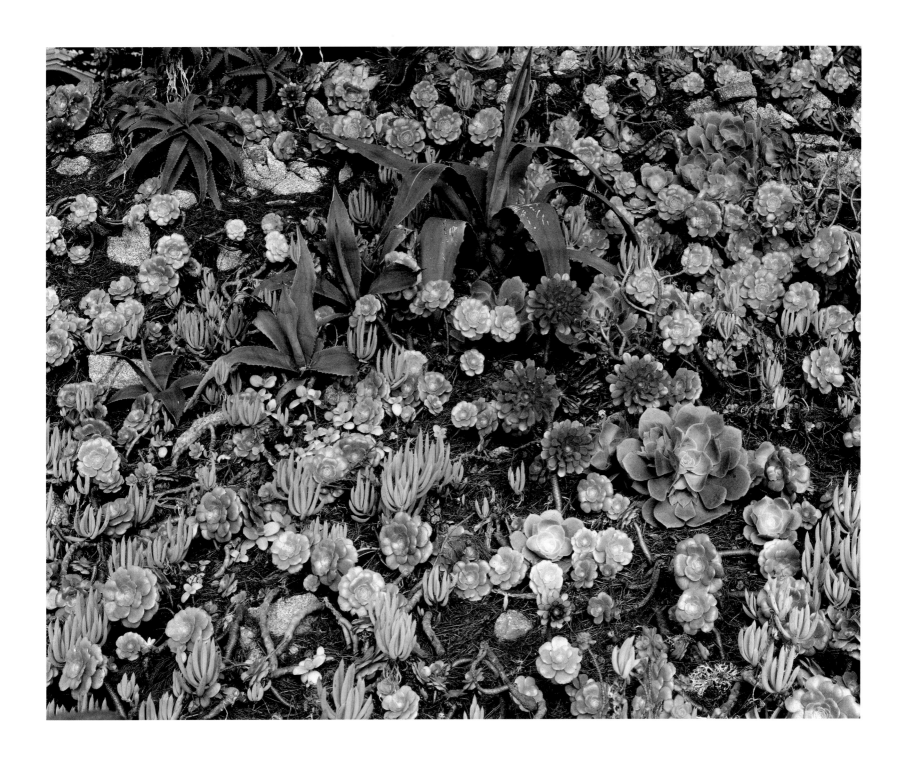

10. KANANASKIS HIGHWAY, ALBERTA, 1990

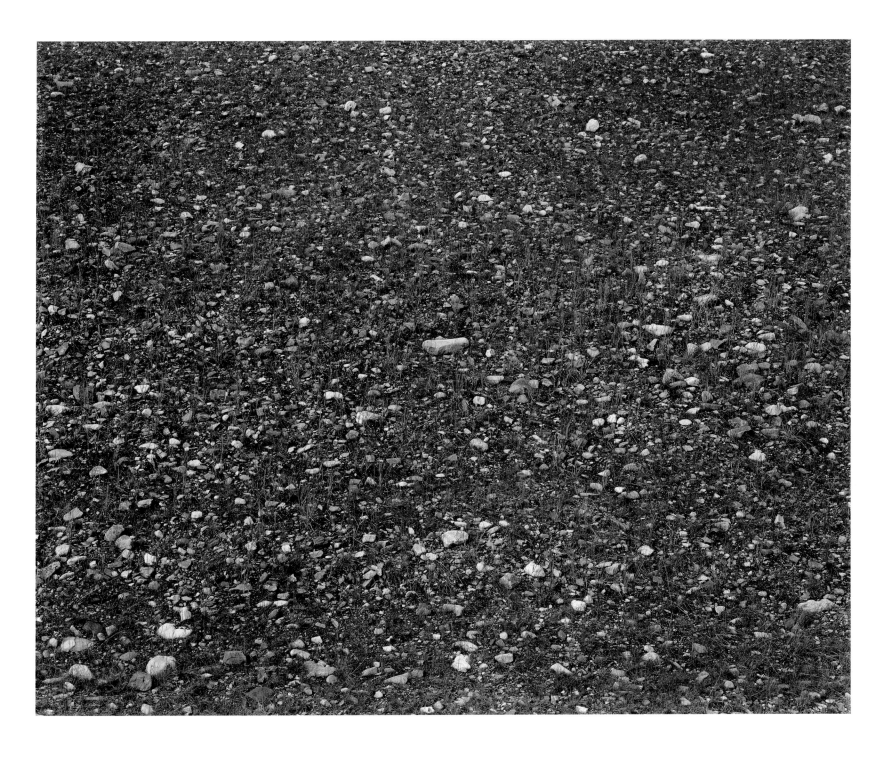

11. NEAR PALOUSE, WASHINGTON, 1990

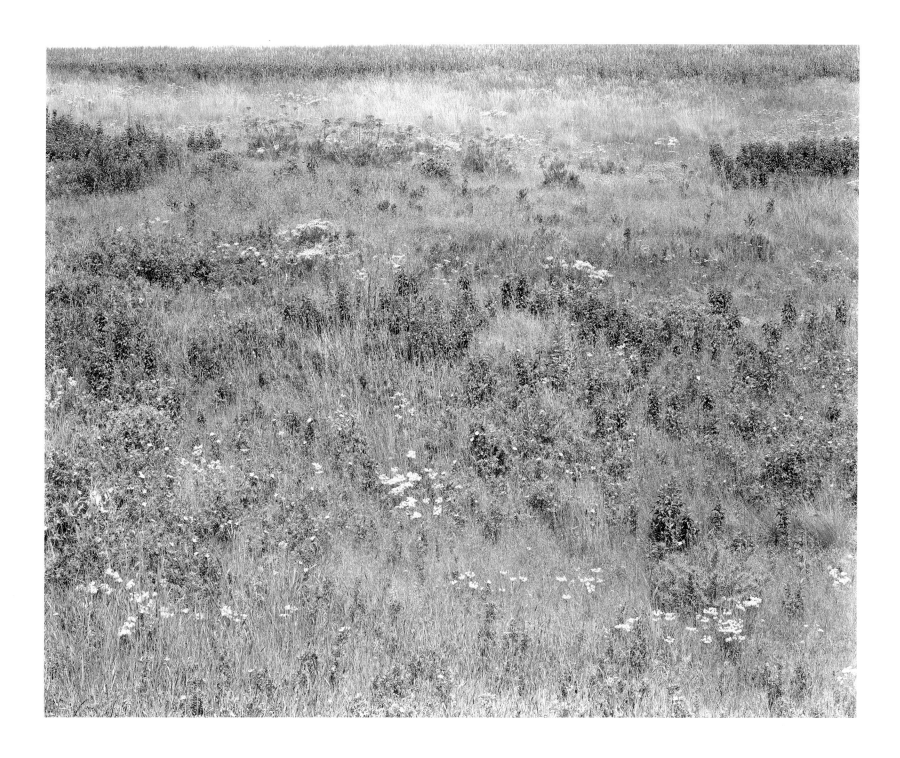

March 20, 1990 *Canyon de Chelly, Arizona*

We entered Navajo country at Window Rock, Arizona, deciding to take the less traveled back roads out of Sawmill on our way to Canyon de Chelly, entering from the southeast onto a "graded" dirt road that soon became a washboard trail and, finally, four-wheel drive territory. With the Indian Country map in hand, we came to a fork in the "road" that did not even appear on this detailed map. Now we trusted only our new compass. (When Michael wanted to buy this compass, I was sure it would be an unnecessary expense. But now it has saved us hours of driving in the wrong direction, and now I like this compass very much.) This was Michael's first time to approach Canyon de Chelly from this direction and my first time to go there at all. We gained altitude until we were driving through tall Ponderosa pines and clean white snow, all at a blazing 15 m.p.h. There were no other vehicles. The adventure heightened as the trail got narrower, rougher, wetter, and more treacherous. On one slippery downhill turn, we had no control of the truck at all. I am sure that I stopped breathing completely while our guardian angels took over. At last, with great joy and relief, we pulled out onto a dry, flat road where we stopped and assessed the damage (only one broken shock bracket), cleaned the windshield and headlights with snow from the roadside, and were finally ready to continue our journey to Canyon de Chelly.

Coming from this direction, our first stop was Spider Rock Overlook—my first look into the canyon. I was in complete awe and could barely speak, and then only in a whisper. I was not prepared to understand and absorb what I was seeing. I was not yet prepared to photograph there. It was too deeply moving to do anything but to look, to marvel, and to be quiet.

July 2, 1993 *Boulder Mountain, Utah*

It seemed there were exciting pictures to be made almost everywhere on the road today between Escalante and Boulder, but, surprisingly, I wasn't seeing anything on this remarkable road that inspired me to set up my camera. Perhaps I wasn't feeling expansive today. Finally, we stopped at a place where the spaces were open and curving, varied and full of visual possibilities—a place that held promise for photographing. I walked around for almost an hour looking at the brilliant light on the white, checkerboarded sandstone hillsides dotted with dark cedars and gnarled, determined trees that seemed to grow directly out of the hard and thirsty rocks. I set up my camera and began to look on the ground glass, but I was seeing only pictures that were similar to ones I had made before. Finally, in this small valley of stone, I turned my camera toward the ground and discovered a groove on the sandstone floor. I felt exhilarated by the way its lines flowed gracefully through the center of the picture with tiny stones balancing the whole. I was reminded of a minimalist painting. It seemed simple, pure and Zen-like, as if a small groove in the earth carried the same information as our planet's great chasms.

12. CANYON DE CHELLY, ARIZONA, 1993

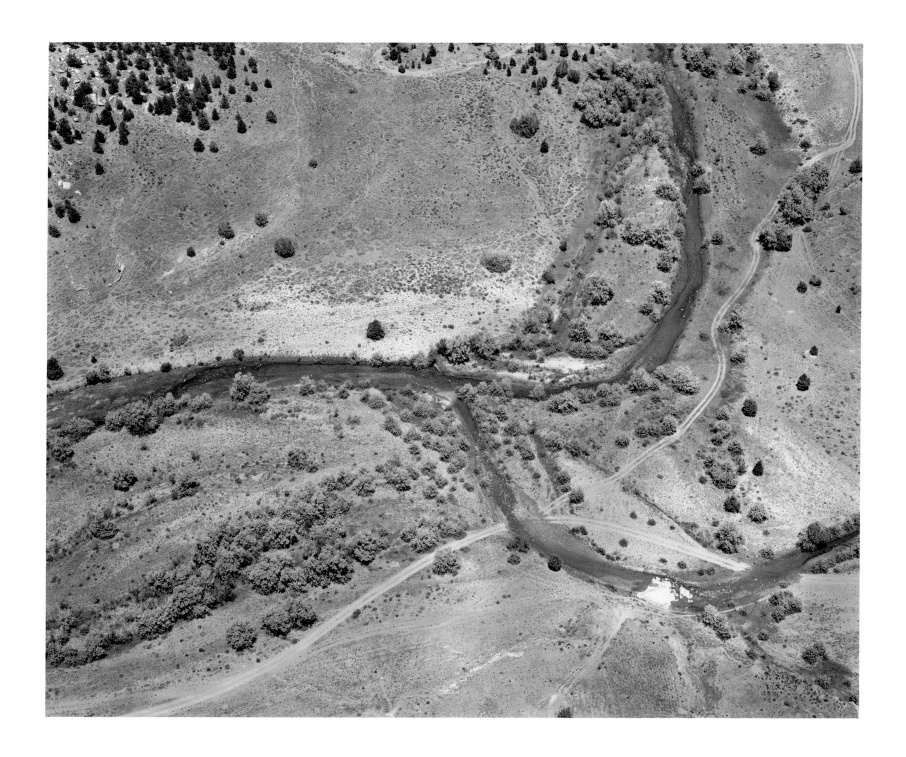

13. BLUE MESA, ARIZONA, 1990

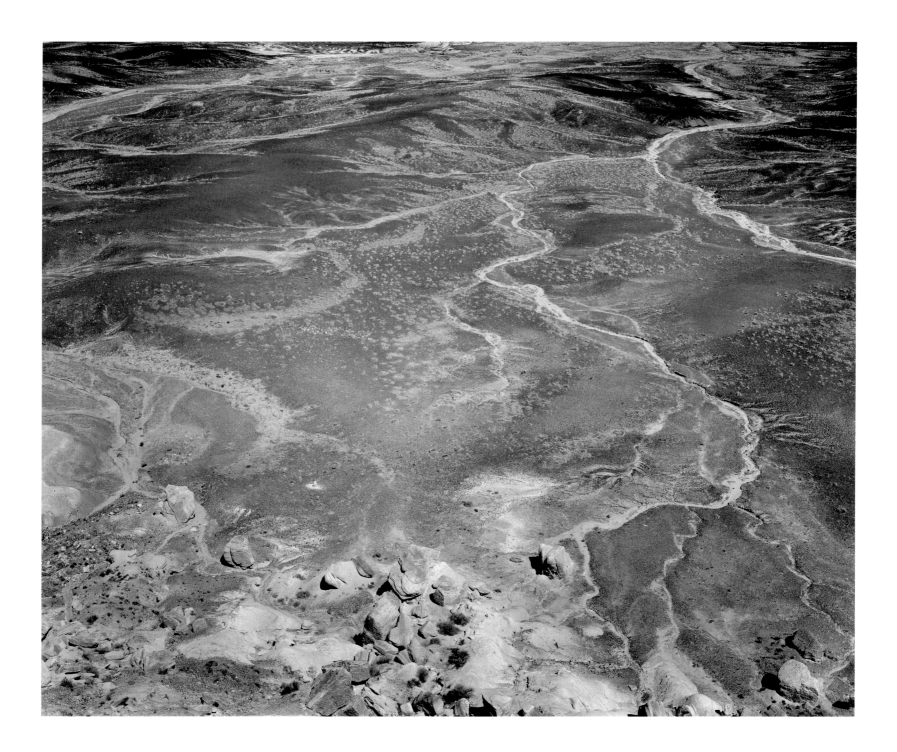

14. YELLOWSTONE, WYOMING, 1991

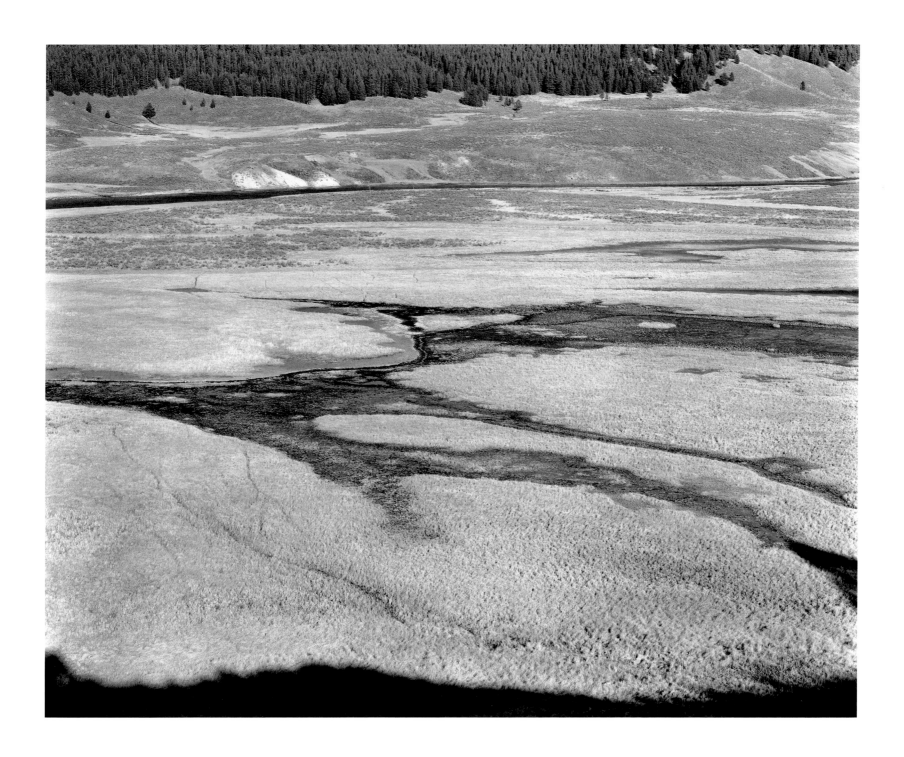

15. CANADIAN ROCKIES, ALBERTA, 1990

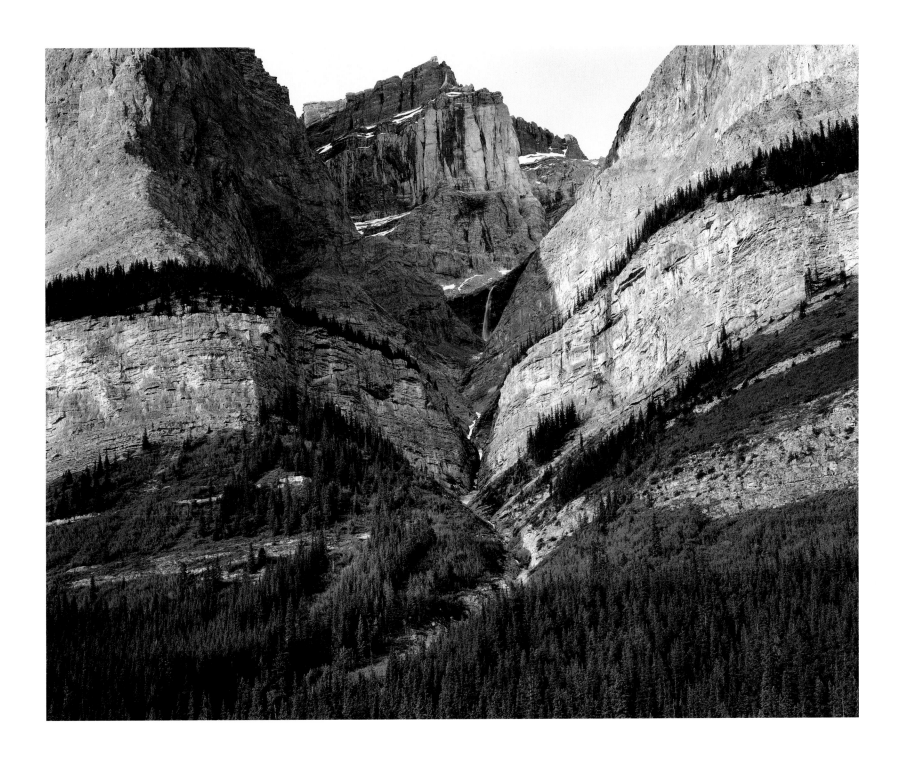

16. YELLOWSTONE, WYOMING, 1991

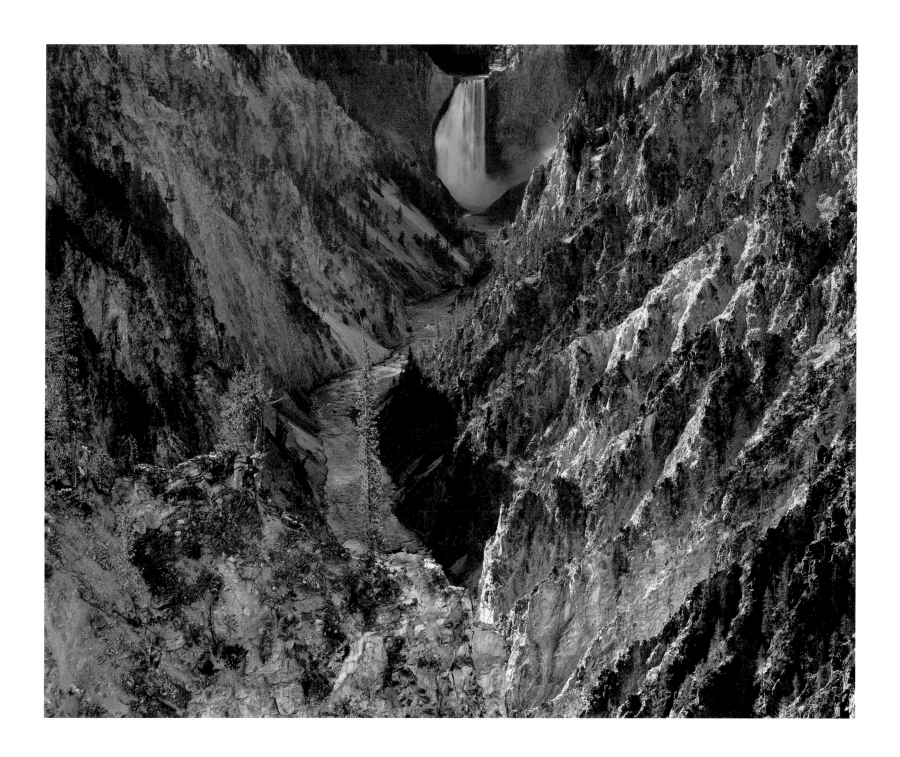

17. GOOSENECKS OF THE SAN JUAN, UTAH, 1991

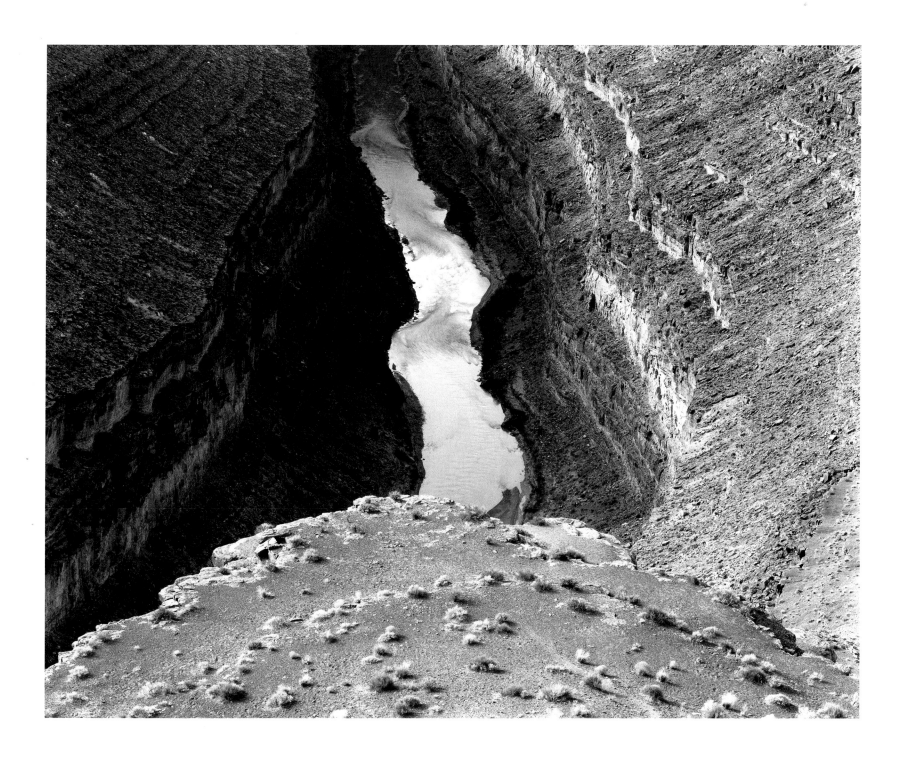

18. NEAR ESCALANTE, UTAH, 1993

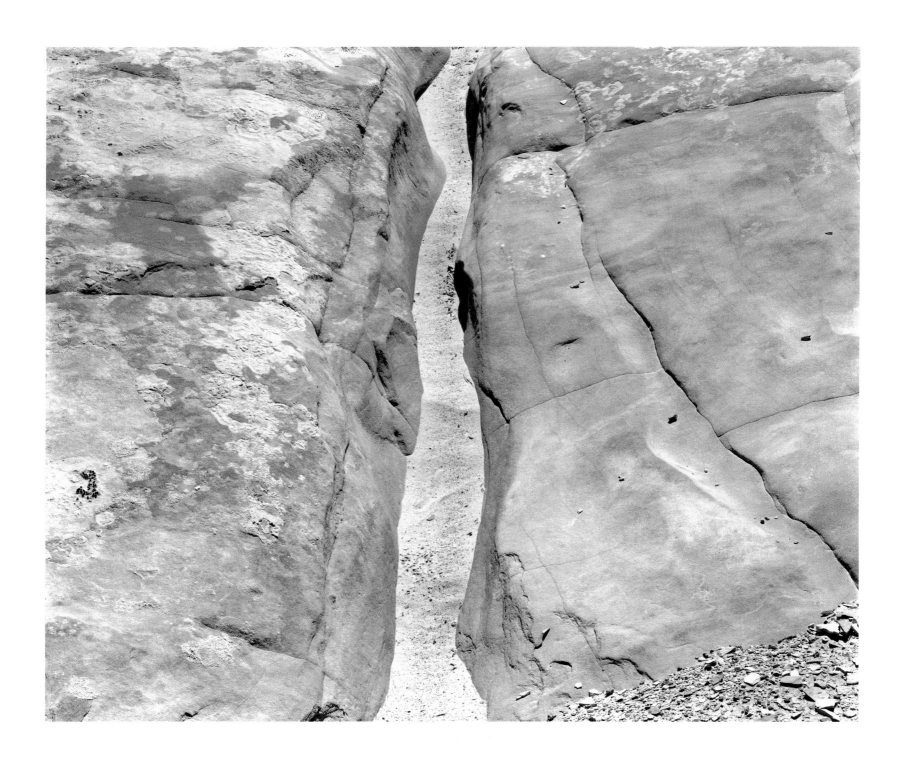

19. NEAR ESCALANTE, UTAH, 1993

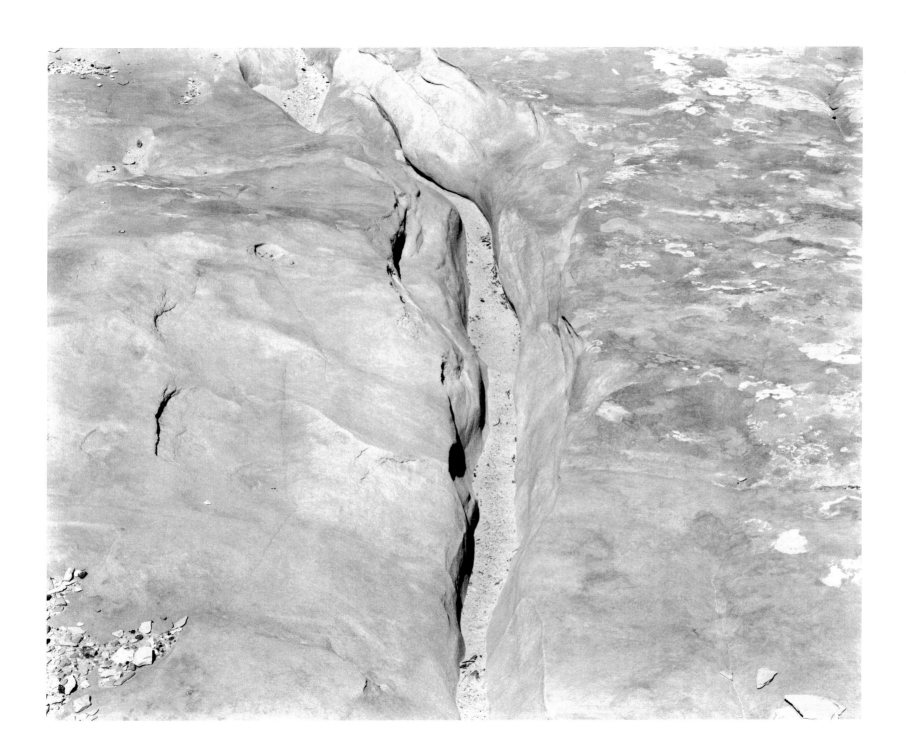

June 21, 1993 *Muley Point, Utah*

Beautiful, clear skies, warm and not too windy today. A godsend—so good to finally be here. We're now far off the beaten path, far from signs or sounds of the "civilized" world. The nights are quiet, peaceful, with black, clear, star-filled skies. I saw a meteor falling into the earth's atmosphere last night, burning blue, red, green and yellow, and seeming to stay suspended for several seconds in its long, slow, descending arc.

After our salad dinners made in the truck, Michael and I spent much time changing film. Getting to bed before midnight has been hard with all of these holders to load. With good light until late day and in this beautiful spot, it has been good to want to use so many sheets of film. I have made some negatives here that I believe are extensions of what I've been doing this year, some challenging and new seeing. I am not trying to do new things; I just feel it happening as a natural extension of my life. I am aware of and not afraid of some new possibilities just now.

June 17, 1993 *White Rim Trail, Utah*

We walked out over the sea of white sandstone, wandering, lingering, enjoying its stark, quiet beauty, its waves of massive spaces between us and the point high over the river. We walked to the edge and sat on a peninsula of rock, listening to the birds far below, their songs echoing and clear between the river and high canyon walls. The river is wide here, and yet we could hardly hear it below us. It is so peaceful in this remarkable place. This strange desert-land of boulders and rock faces continually reminding that they have lived for millions of years—being shaped, layered, broken, eroded, pushed up, melted, compressed, expanded—persisting and evolving, surviving through ages longer than the mind can comprehend. We are just passing through this time with no more significance than a single gnat, capable of much harm and of little or no benefit to this fragile environment.

20. GOOSENECKS OF THE SAN JUAN, UTAH, 1991

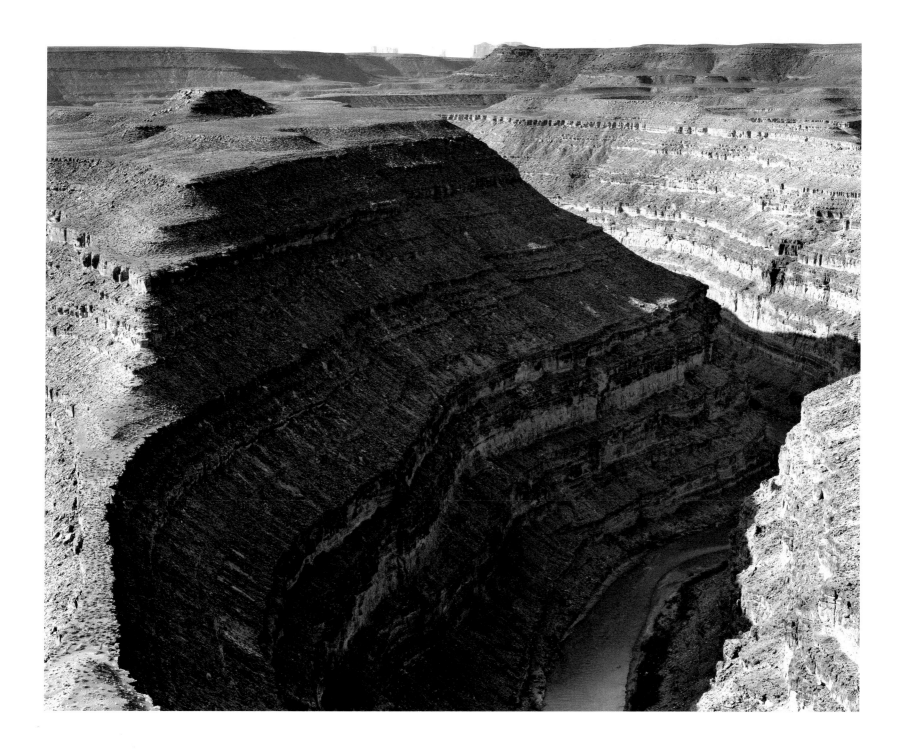

21. CANYONLANDS, UTAH, 1993

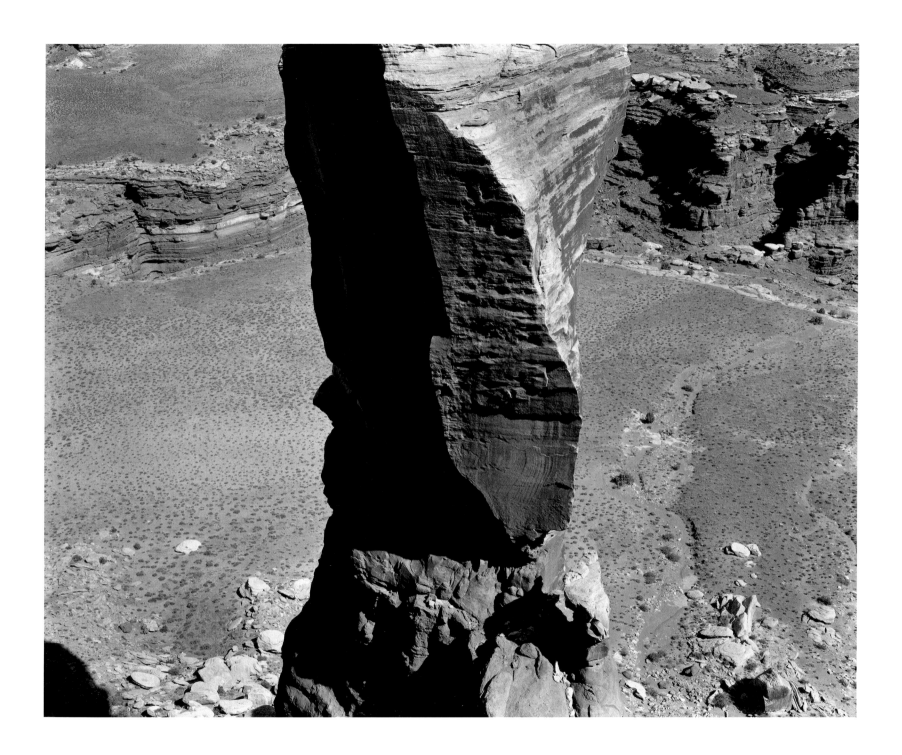

22. MULEY POINT, UTAH, 1993

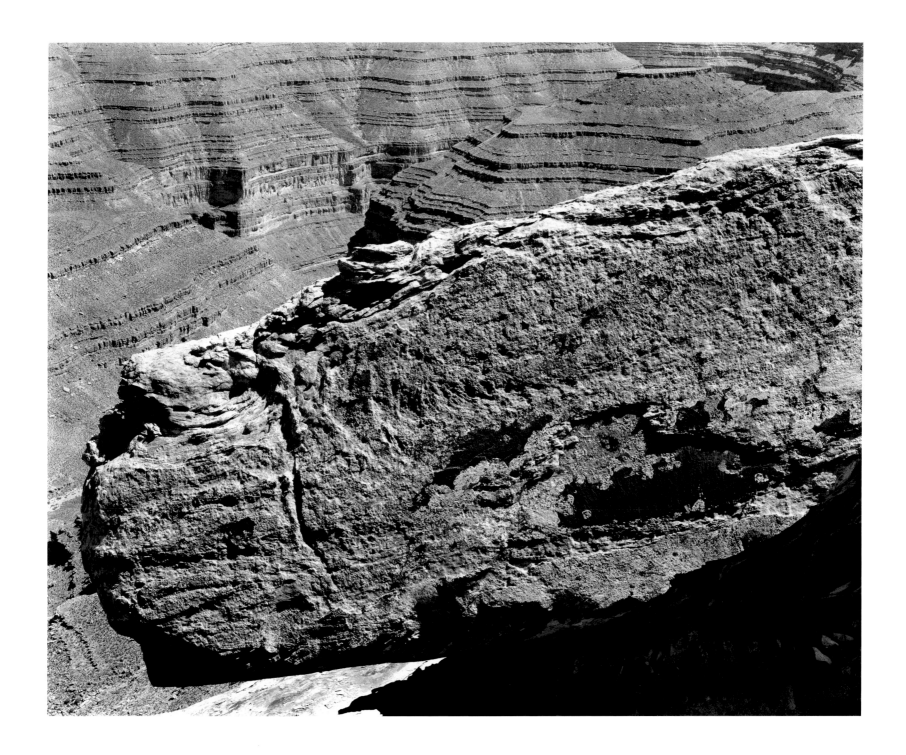

23. LAKE POWELL, UTAH, 1993

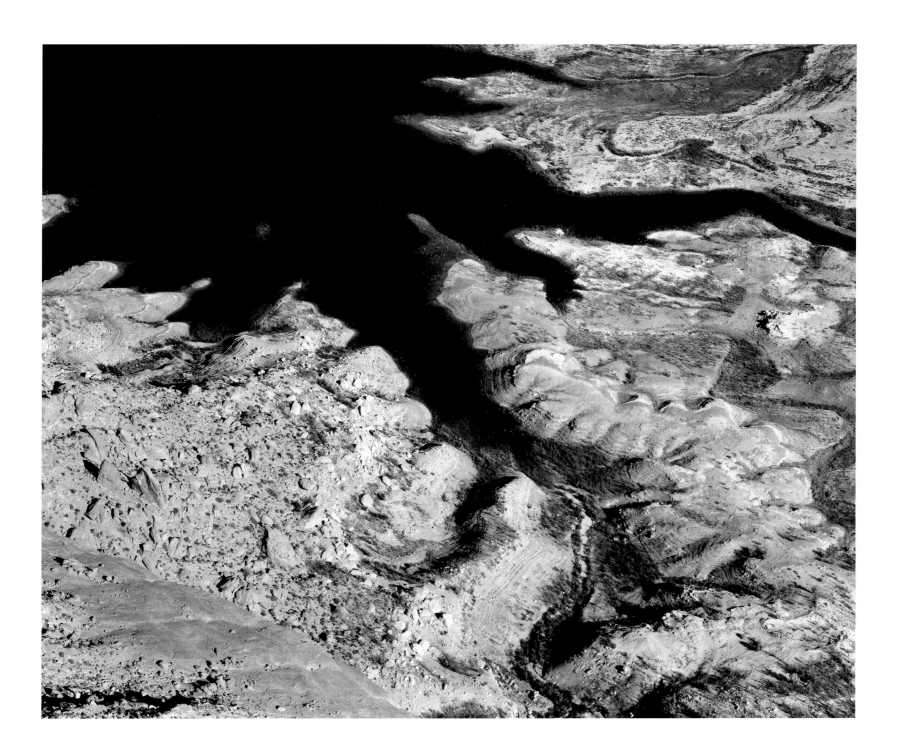

24. THE WEDGE, UTAH, 1993

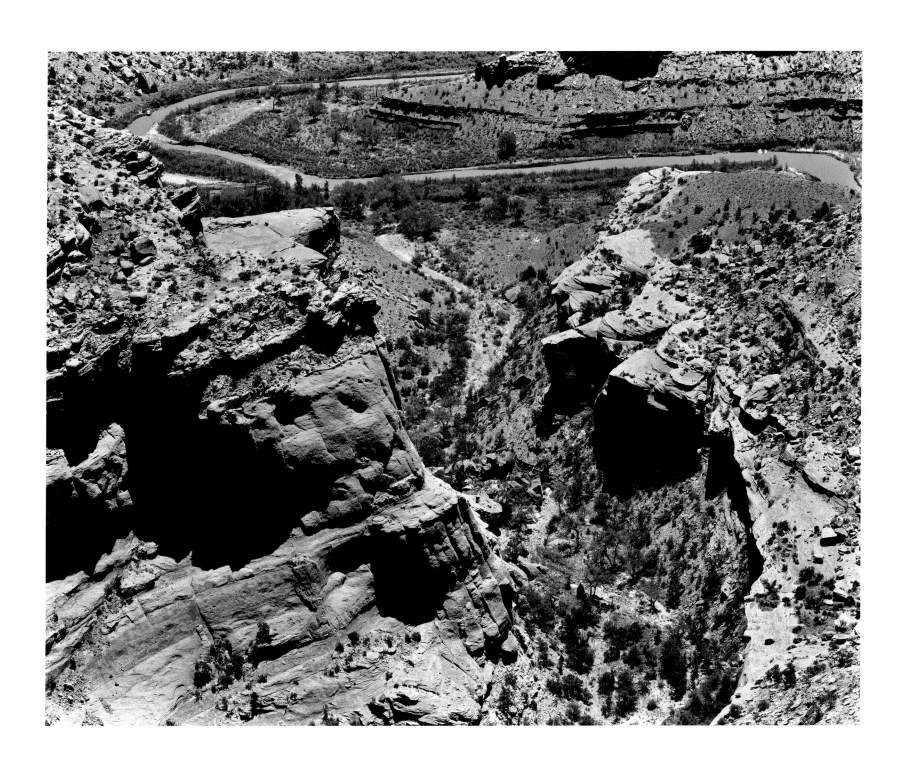

25. CANYONLANDS, UTAH, 1993

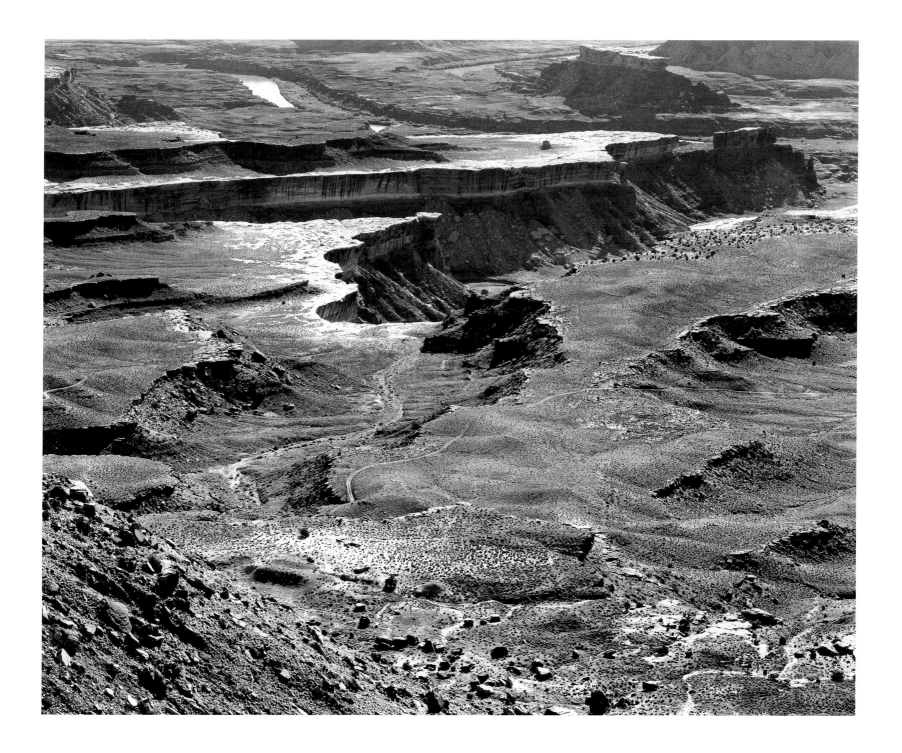

26. THE WEDGE, UTAH, 1993

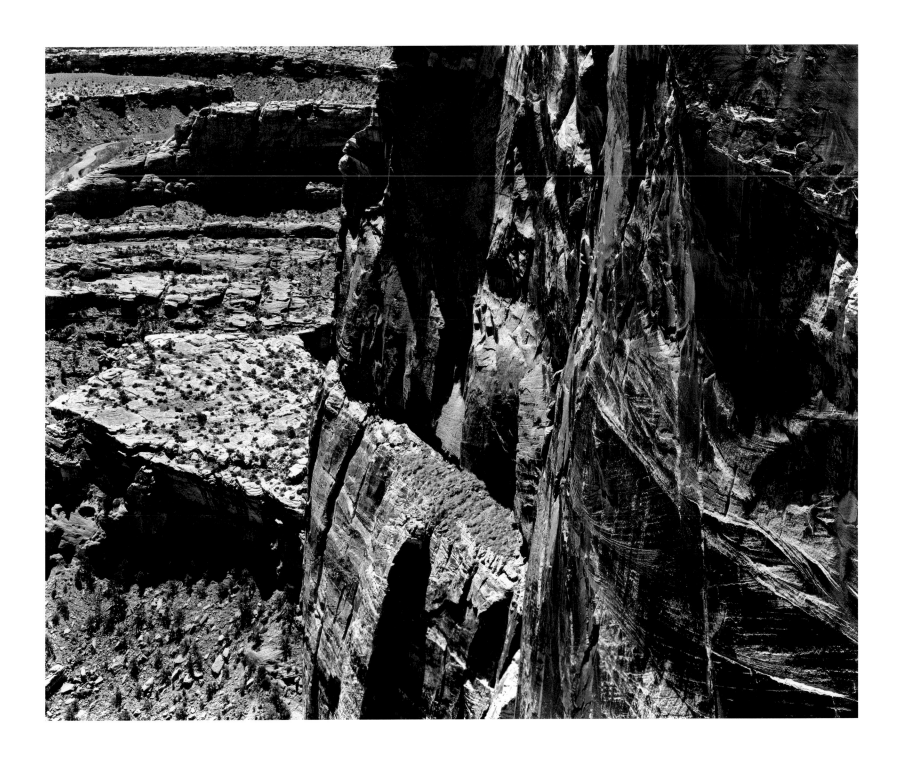

October 18, 1991 *Toroweap, Grand Canyon, Arizona*

Out of St. George we took an unmarked dirt road through the desert on the way to Mt. Trumbull and a small section of the Kaibab National Forest—all part of the arduous 80-mile journey over dirt and rock to Toroweap. This road/trail through the desert became extremely narrow and rough as we carefully climbed the steep and treacherous switchbacks up to Mt. Trumbull. Suddenly, we were in a very different environment as we emerged into a forest of pines and cool air. Then, over the mountain and back into the desert again as we slowly made our way down to the rarely visited Toroweap Overlook, the only point where one can be directly above the Colorado River in the Grand Canyon without hiking to get there. In earlier years, it was even less frequently visited; now, more and more adventurers are making the long and dusty drive.

Toroweap is a magical place, a place where one can walk along the natural, unguarded edges of the canyon's rugged rim 3,000 feet above the river, a place where one is relatively close to the opposite canyon wall, looking to the enormous and ancient layers of time that sculpted the earth as they defined their histories in geologic formations full of information, full of secrets. And it is so quiet. We cannot even hear the birds that we see flying in the canyon below us. Being at Toroweap feels so good that we have decided to camp here for three days instead of two.

We walked around for hours, photographed much, and had our dinner while sitting on the edge of the rim. In the evening we hiked out to a far overhanging rock facing westward, watching the colors of sunset change, softly at first, then more concentrated and intense until we were consumed in a deep red glow cut only by the gleaming ribbon of the Colorado River flowing toward infinity.

October 19, 1991 *Toroweap, Grand Canyon, Arizona*

To my surprise and horror, I discovered a light leak in my lens board this afternoon. This comes after a full day's work making photographs I could never recreate, and after a month of working in other places that I may never return to. Although I have used several other lenses, this one got used all too often. I checked my negative record to see just how often—my heart sank, I started crying, then screaming with rage. I should have checked it more carefully when it came back from being mounted in a new lens board just before the trip. But, alas, two tiny holes were visible when I faced into direct sun, but only when I looked through the darkened bellows at an oblique angle. It was completely by accident that my eye caught the barest glimpse of the holes just as I was about to place the film holder. They have probably fixed their fatal glints upon many new negatives. I was furious.

I seemed to take hours to recover from my doldrums. Why did I feel so deflated and let down? After all, what I have seen is in my head forever and that is the most important thing. Just to be in this place, with no camera, is worth far more to me than these negatives. I foolishly bemoaned my loss for much time, and finally recovered only when Michael insisted I set up my camera again and look at a particular place he had seen and thought I might like. I put a 4x5 reducing back on my 8x10, used a 30" lens, and looked to the far walls of the canyon in the late day light. It was dazzling. My spirits were lifted. As I moved the camera on the tripod just a bit in each direction, entirely new pictures were continually revealing themselves on the ground glass—intricate and glowing details between rich and deep shadows—vignettes of the world as if they were abstract paintings. I felt restored and rewarded. Thank you, Michael.

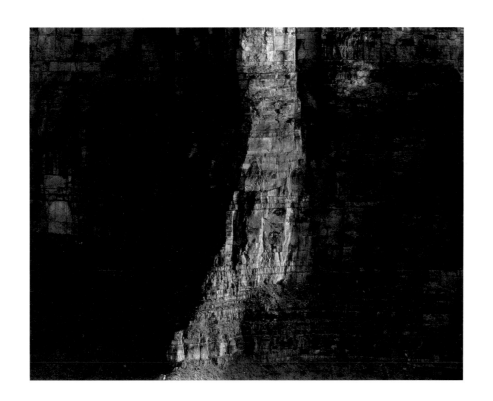

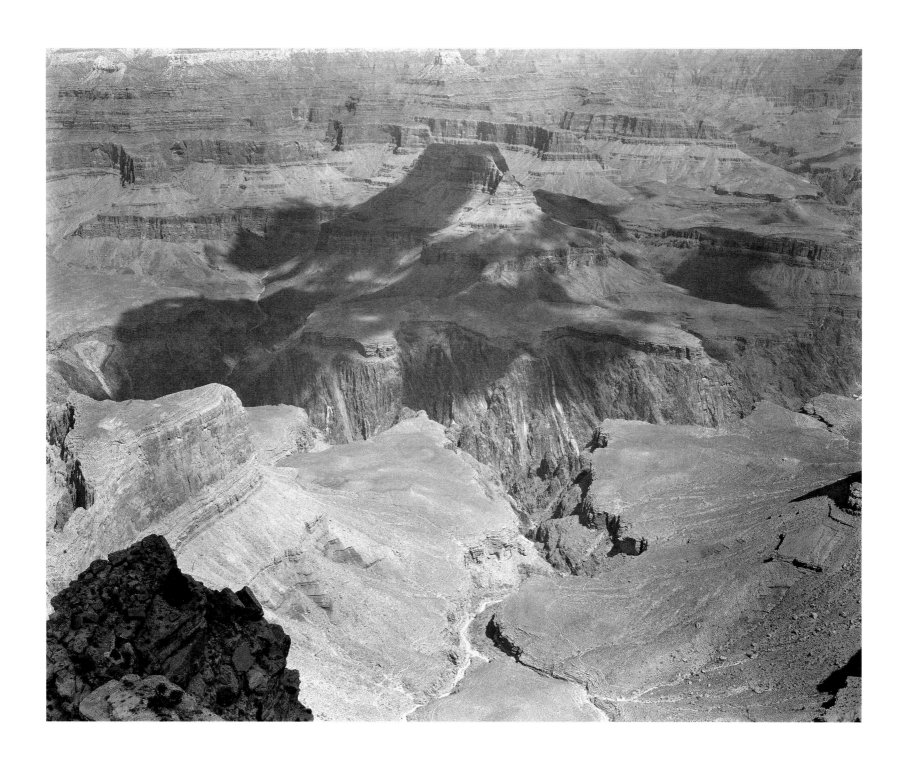

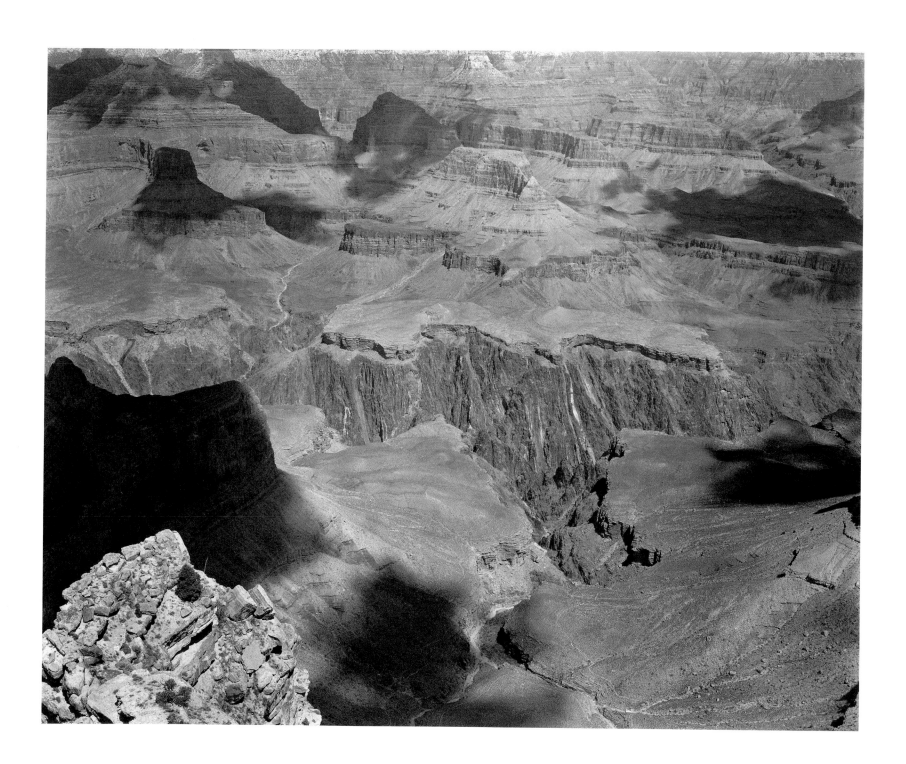

29. TOROWEAP, GRAND CANYON, ARIZONA, 1991

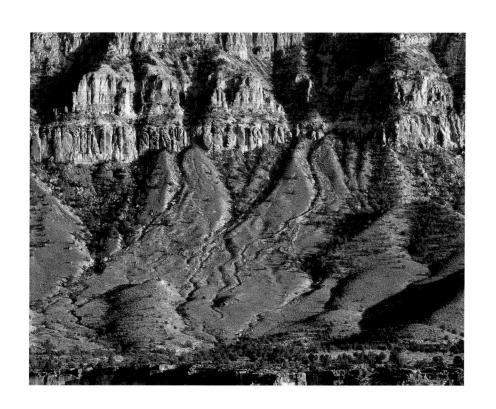

May 5, 1993 *Colorado River in Grand Canyon, Arizona*

We found a quiet and private place in a nearby side canyon in which to camp and sleep under the stars—a remote spot beside a trickling stream with its sounds of small waterfalls dropping into pools of perfectly clear water, all descending from this narrow canyon of schist. A chorus of tree frogs and other nocturnal desert creatures accompanies. As we look up toward the night sky, the small canyon forms towering black walls with lacy edges at the top, creating a U-shaped ceiling roofed in deep blue velvet sky with bright holes of stars.

May 12, 1993 *Colorado River in Grand Canyon, Arizona*

The canyon draws me into herself—this mother earth pulling me back to the womb. To get to my mother earth, I needn't walk far; I need only be still and listen to be in the natural rhythms of the universe, to look—seeing, to listen—hearing.

I sit quietly and alone in this spot in the canyon, listening to the small waterfall beneath my feet, savoring its sound, watching its natural flow. Water, always a life giver, finds its own way—finds its own energetic path of meandering. When I move away a bit, I can hear the birds—oh, how hard it is to get the vibrations of the modern and human-made world out of my ears—the voices, planes, motors. To be in a natural place with only natural sounds becomes more and more difficult, becomes sacred.

May 24, 1993 *Romana Mesa, Utah*

When I am photographing, my intellectual choices seem to be zooming by without effort or notice, for I am so caught up in the excitement of the seeing on the ground glass. I am totally absorbed in the wonder of the activity and the energy that it elevates. My emotions and all my senses seem to be streaming into the process.

July 5, 1993 *Horseshoe Canyon, Utah*

I do not photograph what I think I should photograph—I photograph what I feel I must photograph. I must, because to not photograph would be stifling a passion within me, holding back a vital and life-giving experience. Making my photographs is thus an essential vehicle for the growth of the life of the artist within me, that part of me which demands growth in order to be more aware and sensitive to the world around me.

July 12, 1993 *Granby, Colorado*

For me, a photograph must reach beyond depicting the reality of subject matter and touch a resonant chord through its abstracted arrangement of space and form. My photographs are on a fine line between recognizable subject matter and total abstraction. They show a real and recognizable world in very sharp focus and yet they are not really about that at all. I think of them as a visual door open to a multitude of emotional responses and unsuspected imaginings.

30. CANYONLANDS, UTAH, 1993

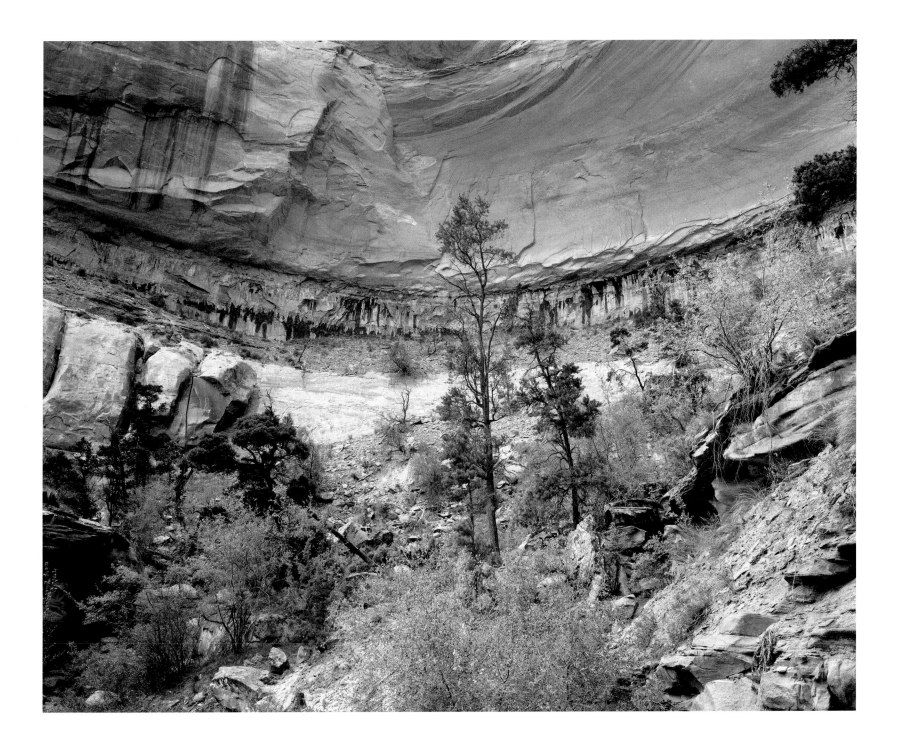

31. FROM ROMANA MESA, UTAH, 1993

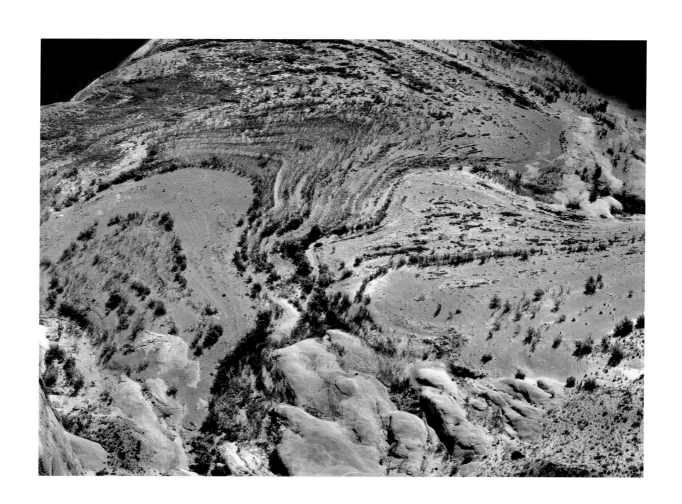

32. WATERPOCKET FOLD, UTAH, 1993

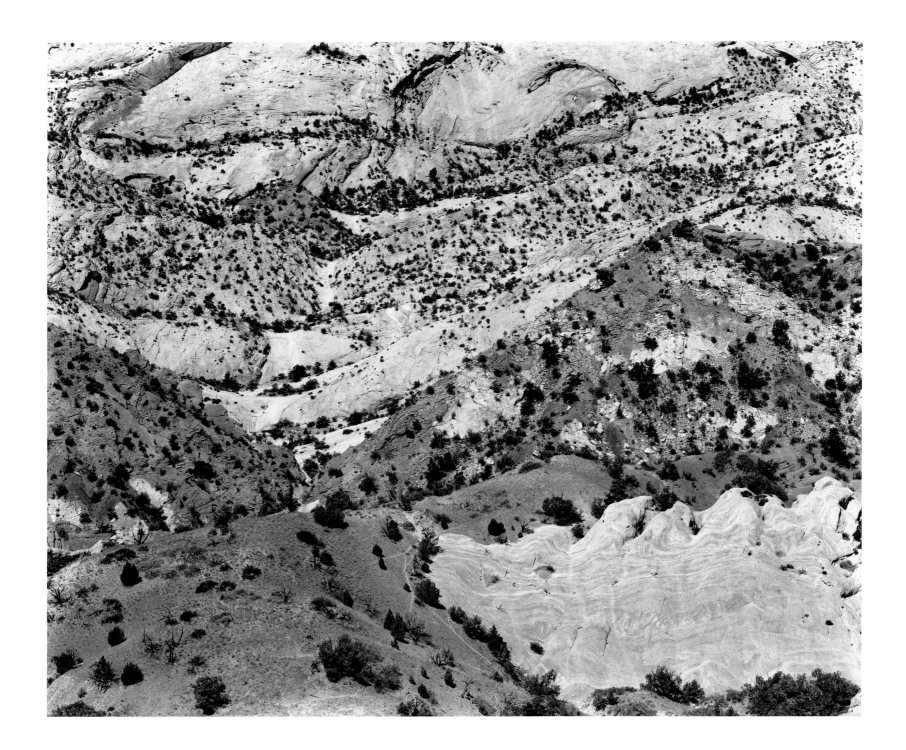

33. NEAR HOPLAND, CALIFORNIA, 1993

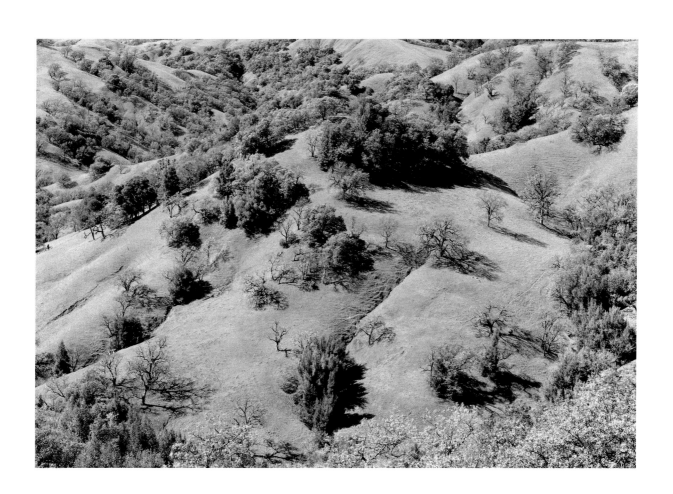

34. NEAR ASPEN, COLORADO, 1991

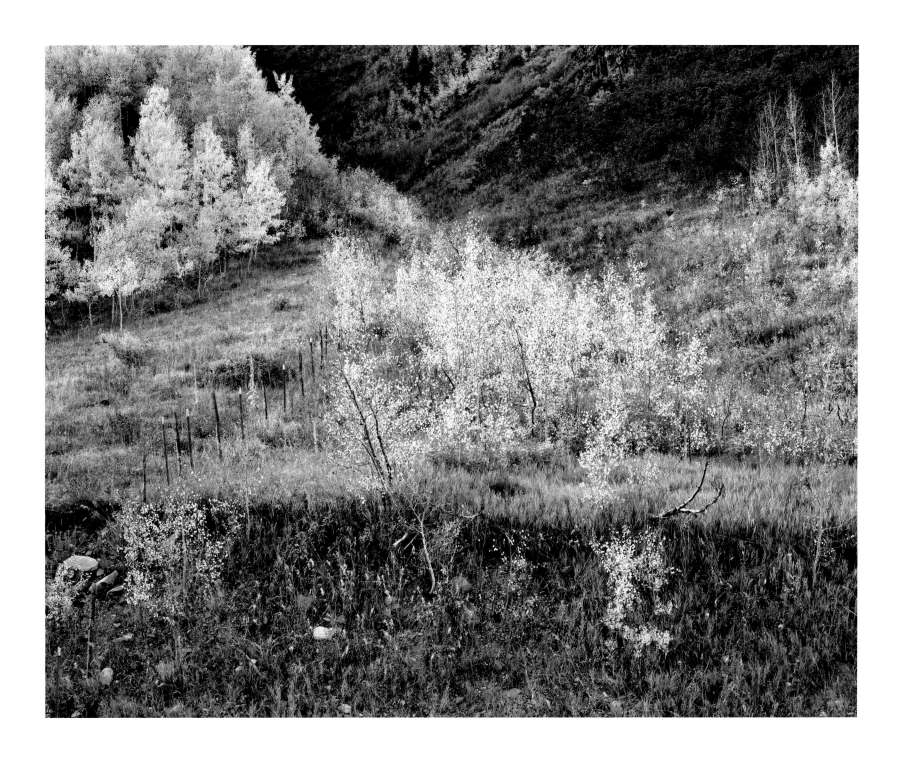

35. NEAR NICASIO, CALIFORNIA, 1990

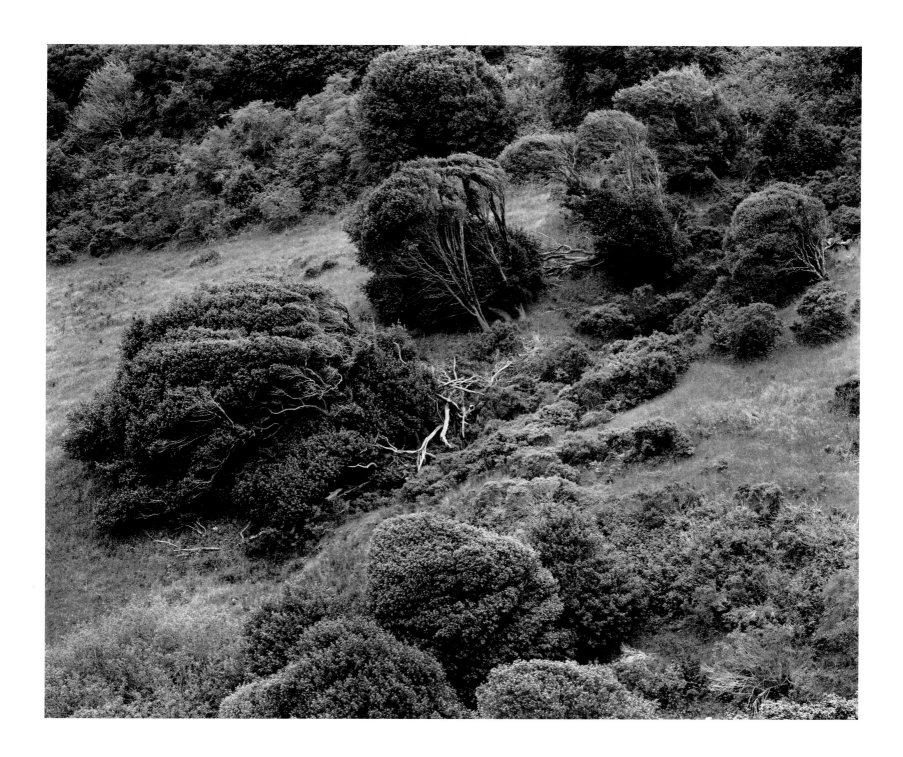

36. NEAR ASPEN, COLORADO, 1991

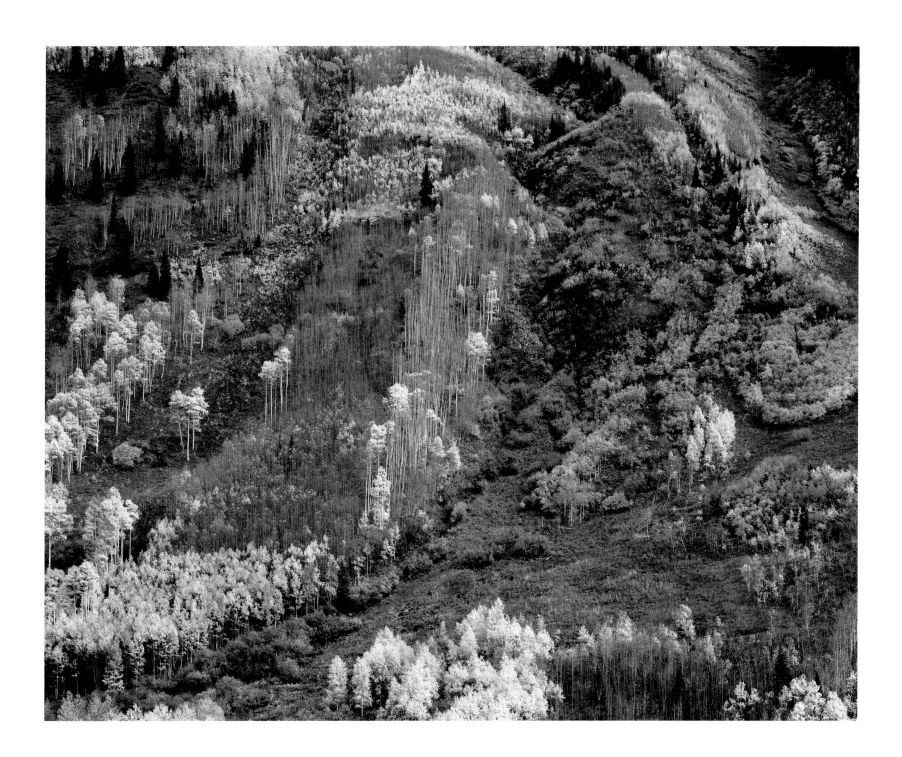

April 14, 1990 *Jacumba, California*

Coming out of the Anza Borego Desert, we were driving on a back road near the small town of Julian where the woods were dense and dark, an area lush and thick with growth. The white stalks, exposed roots and tangled undergrowth struck me as something "yes" immediately, as if I were seeing not a place, but a mood out of a long forgotten dream or distant memory. It was a place that seemed very obscure, yet it touched a personal chord.

There were no distinguishing characteristics here to capture the eye of most travelers. There was nothing beautiful in the classical sense, but it was indeed beautiful: full of movement in spaces defined by flowing, luminous lines. Each way I moved the ground glass, something exciting happened—the dark moody spaces, the bright dead stalks, the bare limbs and roots, the delicate plants—all reminded me of the perfect and delicate lines of a Rembrandt drawing.

May 30, 1990 *In the air—Portland, Oregon to Dallas, Texas*

Forms in nature—endless variety of colors, shapes, textures, and rhythms. From the smallest discernible detail to the biggest view, all are in a kind of harmony and natural balance too large and too perfect for me to comprehend. From the tiniest seed and insect to the largest mountain range or river, everything moves in curving, meandering, pulsating rhythms that reveal a common denominator—the energetic force that formed them all and continues to form and shape every natural thing. Nothing is the same, yet everything is clearly connected.

June 12, 1990 *Sucia Island, Washington*

I continue to be amazed at how the lens and ground glass find my pictures for me. It is almost as if pre-selecting subject matter gets in the way. I realize that I seldom make photographs of what originally caught my eye and caused me to set up my camera. It would never be as thrilling if I knew in advance what would happen. Most of the time, much nicer things happen when there is the possibility of chance discovery. Subject matter becomes abstraction. Abstraction becomes a new adventure.

37. NEAR JULIAN, CALIFORNIA, 1990

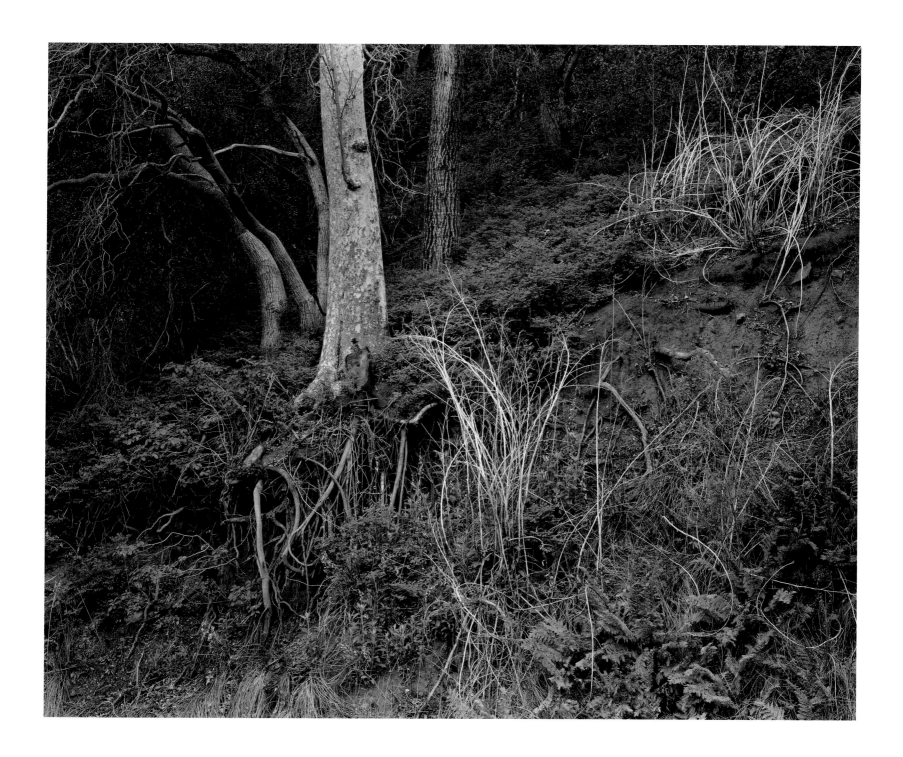

38. BAYOU LE BATRE, ALABAMA, 1989

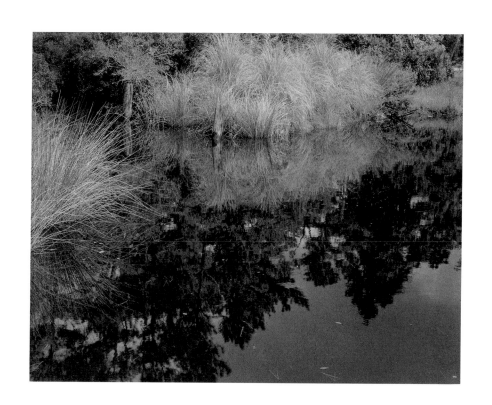

39. NEAR JASPER, ALBERTA, 1990

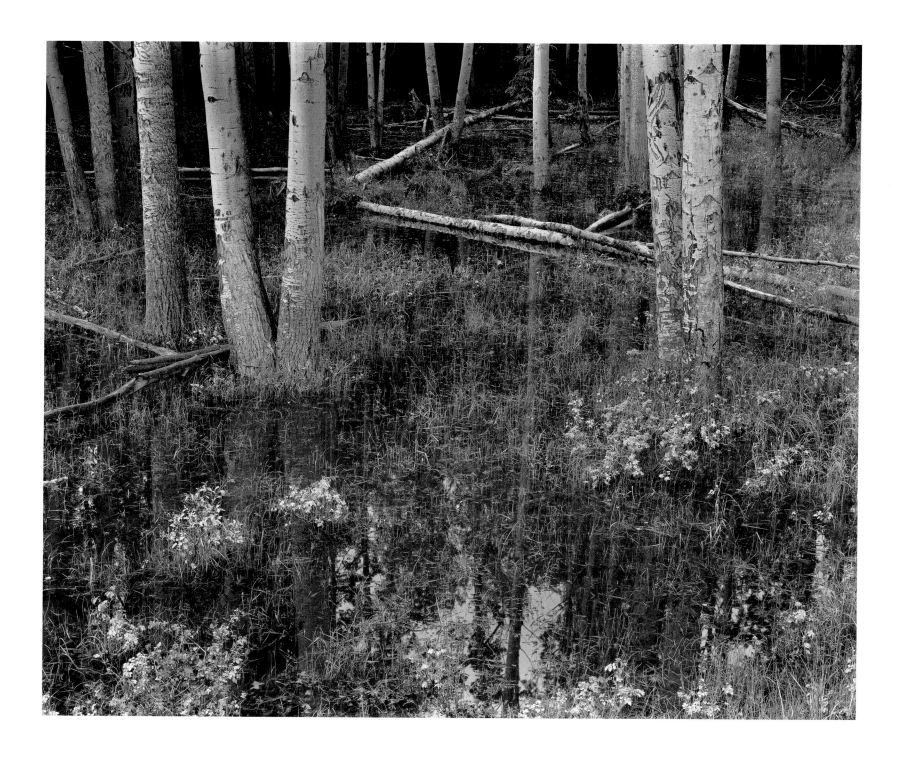

40. ISA LAKE, YELLOWSTONE, WYOMING, 1991

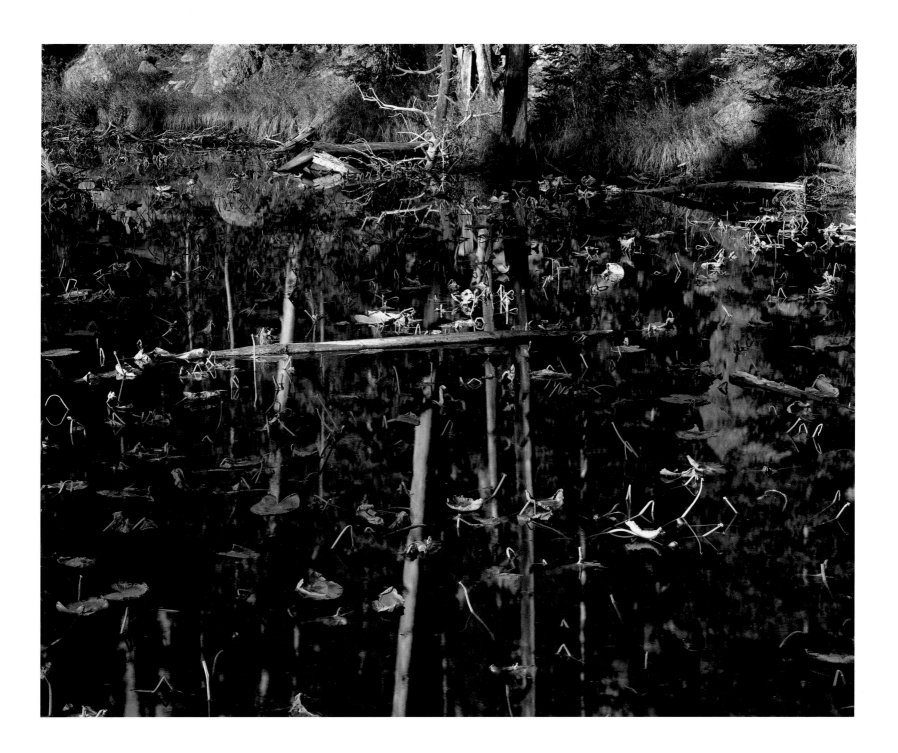

41. OLYMPIC PENINSULA, WASHINGTON, 1990

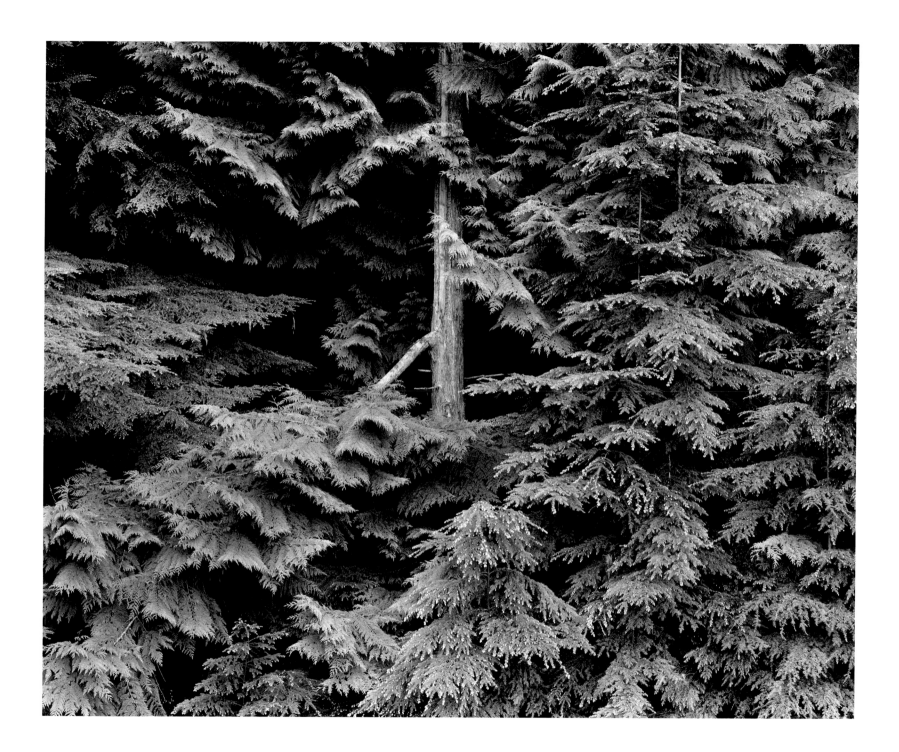

Designed by P. M. Design Studios
Typeset in Monotype Centaur and Monotype Bembo
by AdamsGraphics, Inc.
and printed on Quintessence
by Gardner Lithograph in laser Silver-Lit™ Tones
marking the first use of this process in the reproduction of photographs
Bound by Roswell Book Binding

For information regarding availability of the photographs:
Paula Chamlee P. O. Box 400 Ottsville, Pennsylvania 18942
610-847-2005